YORK

THE POSTCARD COLLECTION

Paul Chrystal

AMBERLEY

By the Same Author:

York in the 1970s
York in the 1960s
York in the 1950s
York and Its Railways
York Churches and Places of Worship
Secret York
Changing York
The Rowntree Family of York
York Places of Learning
York Industry
The History of Chocolate in York
In and Around York
York Then and Now
York Villages
Old Haxby and New Earswick
Hartlepool: The Postcard Collection

First published 2017

Amberley Publishing
The Hill, Stroud, Gloucestershire, GL5 4EP
www.amberley-books.com

Copyright © Paul Chrystal, 2017

The right of Paul Chrystal to be identified as the Author of this work has been asserted in accordance with the Copyrights, Designs and Patents Act 1988.

ISBN 978 1 4456 5217 7 (print)
ISBN 978 1 4456 5218 4 (ebook)

British Library Cataloguing in Publication Data.
A catalogue record for this book is available from the British Library.

Origination by Amberley Publishing.
Printed in Great Britain.

INTRODUCTION

York is one of the most historic of Europe's cities. It has a heritage that is second to none. Little wonder, then, that tens of thousands of different picture postcards have been published celebrating that history and heritage in all its glory. This book provides a small selection of these, but it is hoped that the 200 or so postcards featured here serve, along with their captions, to provide a comprehensive history of the city and a guide to its many treasures, buildings, streets, industry, shops, rivers, walls and bridges, and the people of York.

The combination of York's magnificent sights, the growing popularity of photography at the turn of the twentieth century, and the ubiquity of the postcard as an efficient and pleasing method of communication – an early form of social media – and our natural propensity to collect and hoard things was nothing less than explosive. *York: The Postcard Collection* exemplifies that explosion.

York has always been a thriving and bustling metropolis. Romans, Vikings, and Anglo-Saxons all exploited its commanding position at the confluence of the Foss and Ouse; the English Civil War simmered here and the gentry came in their well-upholstered droves in the seventeenth and eighteenth centuries to enjoy the fine and elegant buildings; churches are in abundance, the minster pre-eminent but only one of many exceptionally beautiful places of worship; medieval city walls still snake around the city, the most extensive and intact in the kingdom; and ancient bars, posterns or gates, and a castle have survived, as have some of the finest buildings left in Europe. All of this – and the fine old streets, alleyways and snickelways – are celebrated in the postcards here, from Edwardian times and onwards, bringing us up to date with the 2015 card depicting the wonderful stained-glass window that celebrates the York soldiers who died in the war in Afghanistan.

The first known picture postcard is thought to have been sent in 1840 to Theodore Hook in Fulham, a writer and practical joker noted for his pranks. Hook may well have sent the card himself as its illustration caricatures postal workers; in 2002 this card was bought for £31,750. As you might expect, most postcards were made from card but others made of wood, copper, silk and coconut are known. Deltiology, as the collecting of postcards became known, soon became all the rage and is now the world's third largest collecting hobby after stamps, coins and banknotes. The word was coined in 1945, formed from the Greek δελτίον, *deltion*, the diminutive of δέλτος, *deltos*, 'a writing tablet or letter', and -λογία, *logia*, 'study'.

We have the French to thank for the early rise of postcard production: the opening of the Eiffel Tower in 1889 boosted the dissemination of the postcard, giving rise to the 'golden age' of the picture postcard from 1898–1919, largely photochromes produced from black-and-white photographs. Predictably perhaps, early postcards often depicted nude women, known as 'French postcards', as many of them came out of France. In Britain, meanwhile, postcards were devoid of pictures. In 1894, there was further impetus when British card publishers were allowed by the Post Office to produce and distribute picture postcards, which could be sent through the mail. The first British picture card was published by E. T. W. Dennis of Scarborough around the same time. Early cards showed landmarks, scenic views – seaside scenes in particular – celebrities, disasters, commercial advertisements, shipping, heraldry and steam trains. They were called court cards (115 mm by 89 mm) but the opportunities for illustration were limited because the message had to be written on the same side as the picture, with stamp and address on the back. In 1899, the Post Office allowed the larger continental size (140 mm x 89 mm) and introduced the 'divided back' in 1902, with message and address sharing the back, leaving the front just for the picture. The postcard as we know it was born.

After this golden age, later periods were the 'time of the linens' (1930–1950) and 'modern chromes' (post-1940), which use colour photographs. In the 1930s, following the French in the previous century, the risqué cartoon-style so-called 'saucy' postcard took the market by storm, selling around 16 million cards a year – the bawdy subject matter and innuendo was the precursor of the *Carry On* films. The most prolific publisher of these cards was Bamforths of Holmfirth.

The majority of postcards in this book are town views from the golden age, probably the most popular genre there is among collectors. York, as suggested above, lends itself perfectly to this type of card.

Famous postcard photographers are legion. James Valentine (1815–79), Frances Frith (1822–98), Fred Judge (1872–1950), and Walter Scott (of Bradford, 1878–1947) spring immediately to mind. However, York has it very own pre-eminent postcard photographer in William Hayes (1871–1940), who was born at No. 24 Newbiggin, son of a Colliergate bootmaker. The Hayes family later moved to No. 29 St John Street. In 1829, William's maternal grandfather, a carpenter, walked the 30 miles from Rosedale to York to help restore the minster after the devastating fire started by Jonathan Martin. William attended York School of Art in St Leonard's (now the Art Gallery). His brother, Thomas, moved to what was then West Hartlepool to be a teacher. William's prolific correspondence with Thomas was often illustrated with sketches of York's sights and events.

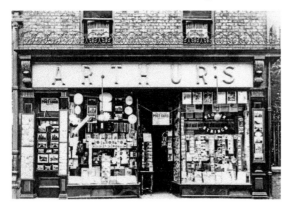

Whole sections of shops were given over to stocks of postcards in Edwardian days. This is Arthur's Postcard Depot in Davygate in 1900.

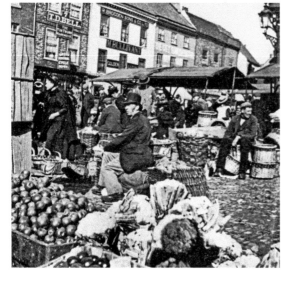

A famous William Hayes photograph showing a farmer selling produce in St Sampson's Square with Bell's Tin Trunk Warehouse, the Golden Lion and the City Turkish Baths in the background.

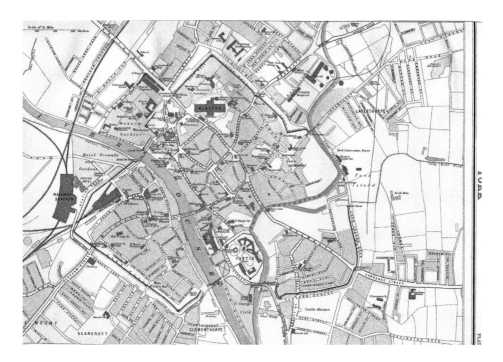

Birds-Eye Views of York

The book opens with two images that are not postcards, but they will help to identify where some of the places depicted over the next ninety or so pages actually are. The first is York as mapped by Bartholomew in 1898. Beneath that is a detail from *The Gardens of the Yorkshire Philosophical Society* (York: 1860) by J. Storey, showing the river, the Yorkshire Museum, the Observatory, Multangular Tower, St Mary's Abbey (left) and St Leonard's Hospital (right). It is now in York City Art Gallery. (Image courtesy of York Museum Trust http://yorkmuseumstrust.org.uk/ Public Domain)

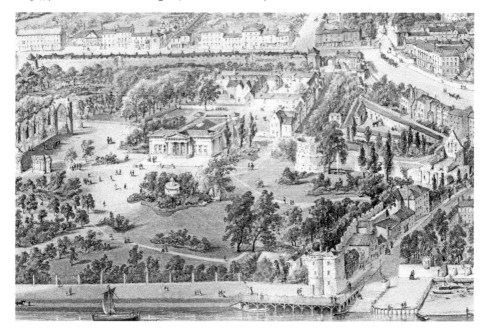

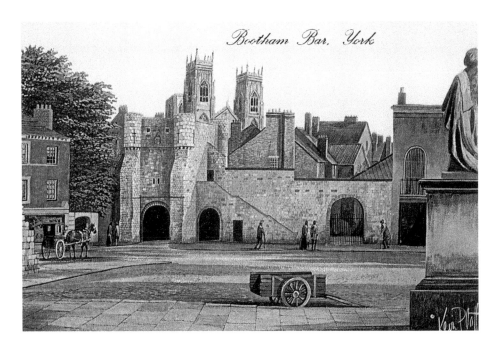

Bootham Bar

Two cards showing Bootham Bar with the minster in the background. The De Grey Rooms are to the right with the William Etty statue just visible on the right foreground of the upper card. Lady Margaret's Arch is on the left foreground. Bootham Bar was originally Buthum, which means 'at the booths' and signifies the markets that used to be held here, standing on the north-western gateway of the Roman fortress and originally called Galmanlith. The barbican was removed in 1831, due in part to complaints by residents of Clifton; it being 'not fit for any female of respectability to pass through' on account of the droppings of animals en route to the cattle market and its use as a urinal by pedestrians. The three statues on the top were carved in 1894 and feature a medieval mayor, a mason and a knight; the mason is holding a model of the restored bar.

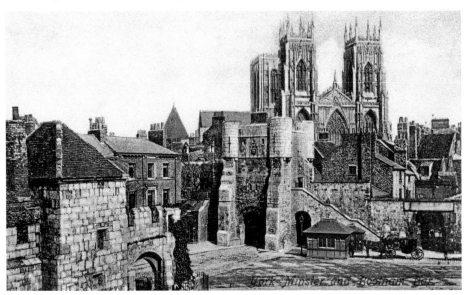

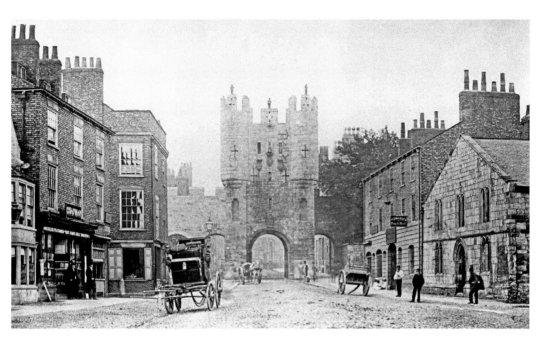

Micklegate Bar
Micklegate Bar with Howard's Punch Bowl on the right and St Thomas's Hospital on the corner of Nunnery Lane. In 1851, it was an almshouse 'for aged widows', taking in permanent residents and travellers for food and lodging. Until 1791, these widows had to beg on the streets for four days every year for their alms. Chapman, the bookseller and stationer, is on the left of the upper photo.

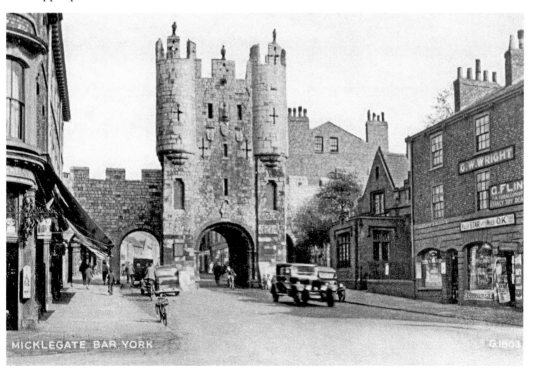

Fishergate Bar and Walmgate Bar

Fishergate Bar is also called St George's Bar, gateway to Selby; chains ran across the River Foss from here to the castle as part of York's defences. The bar was blocked in 1489 after rebels damaged it in the Peasants' Revolt, with the fire damage still visible. It was eventually reopened in 1827 to allow access to the Cattle Market. In Elizabethan times it was a prison for 'rascals and lunatics'. The John Smith's Phoenix Inn Brewery can be seen to the right in Long Close Lane. The building on the left was Falconer's, the furnishers. St George's Roman Catholic Church is just visible in the distance, built in 1850 to meet the spiritual needs of Irish immigrants. The fourteenth-century Walmgate Bar is in the lower card from 1905. The wooden part is Elizabethan and was used as a prison during the First World War. The Parliamentarians shell damaged it during the siege of York.

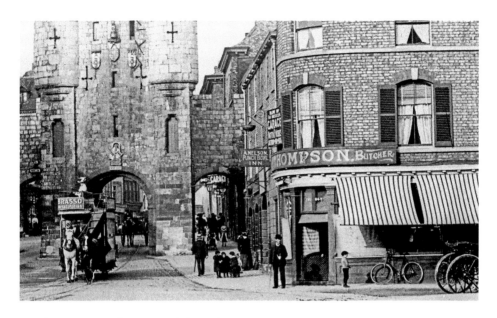

Monk Bar, The Red Tower and the Fishergate Postern Tower

A wonderful image of Monk Bar showing a horse-drawn tram with an elegant female passenger, Nelson's Punch Bowl Inn, a garage where the model shop now is, and a little boy admiring a bicycle outside the butcher's where Bulmer's recently was. The Red Tower is so named after the colour of its brickwork – all the other walls, bars and towers being built with Tadcaster limestone. Its walls are 4 feet thick. The tower was built around 1490 by Henry VII and restored in 1857 after being damaged in the siege of York. The original roof was flat and it boasted a projecting toilet. It was also known as Brimstone House when it was used as a gunpowder warehouse; around 1800 it also served as a stable. The card also shows (the second) Fishergate Postern Tower. When Fishergate Bar was destroyed in 1489, there was urgent need for another gateway to the city so, in 1501, the council decided that 'ther shal be a substanciall posterne maid at Fyschergate, which nowe is closed up'. Presumably, the postern we see today was rebuilt soon after 1502.

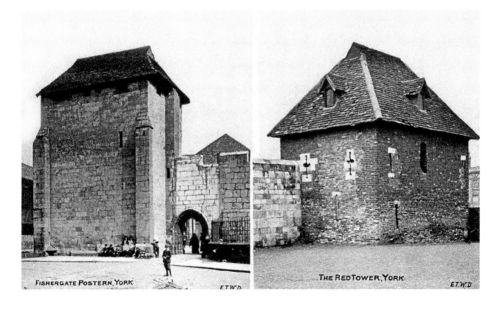

FISHERGATE POSTERN, YORK

THE RED TOWER, YORK

9

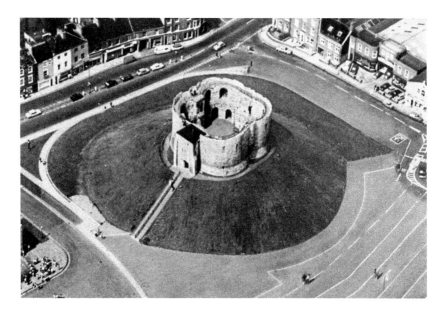

Clifford's Tower

Clifford's Tower was originally King's Tower, or even the 'Minced Pie', but from 1596, it assumed the name of Francis Clifford, Earl of Cumberland, who restored it for use as a garrison after it had been partly dismantled by Robert Redhead in 1592. An alternative, but spurious etymology comes from Roger de Clifford whose corpse was hung there in chains in 1322. The first castle was built in wood by William the Conqueror – his first English castle – when he visited to establish his northern headquarters in 1190. It was burnt down when 150 terrified York Jews sought sanctuary here from a fiercely anti-Semitic York mob. Faced with the choice of death or forced baptism, many of the Jews committed suicide and 150 others were mercilessly slaughtered. The castle was rebuilt in stone by King John and Henry III and housed the kingdom's treasury in the fourteenth century. Robert Aske, one of the prime movers in the Pilgrimage of Grace, was hanged here on 12 July 1537. Deer grazed around the tower for many years and it became part of the prison in 1825.

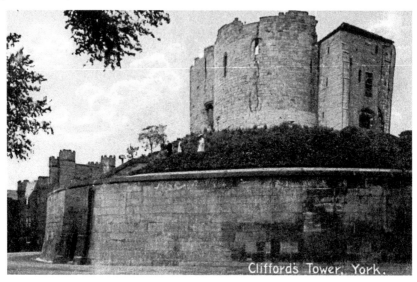

Clifford's Tower, York.

The Multangular Tower, Lendal Tower and Bedern

The Multangular Tower in the Museum Gardens is the most obvious and best-preserved structure from the Roman walls, built as one of a series of eight defensive towers. Although the walls are the work of Septimius Severus (r. 193 to 211 CE), the tower is a later addition by Constantine from 310–320 CE. It has ten sides but four additional sides to the rear are missing to allow access to the interior of the tower. Lendal Tower was built around 1300 as part of York's defences and housed an iron chain that could be extended to Barker Tower opposite to keep out hostile boats and to help extract tolls. In 1677, it was leased for 500 years to the York Waterworks Company for two peppercorns (a peppercorn rent) and provided York's water supply until 1836 when the dedicated red-brick engine house was built. The peppercorn rent is payable annually until 2177. Bedern was an unsavoury, violent and impoverished place at the best of times, with 300 people sharing just five toilets according to one report. For the thirty-six Vicars Choral of York Minster, this was their first home from 1349.They had been indulging in 'colourful nocturnal habits' and were rehoused in St William's College so that their behaviour could be more closely monitored.

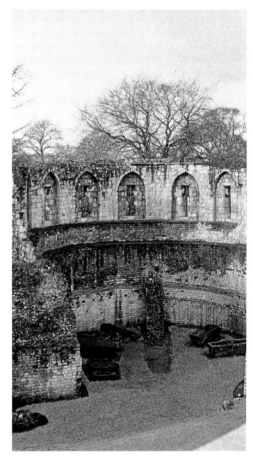

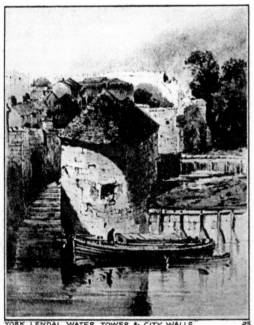

YORK. LENDAL WATER TOWER & CITY WALLS. 23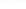

BEDERN 24

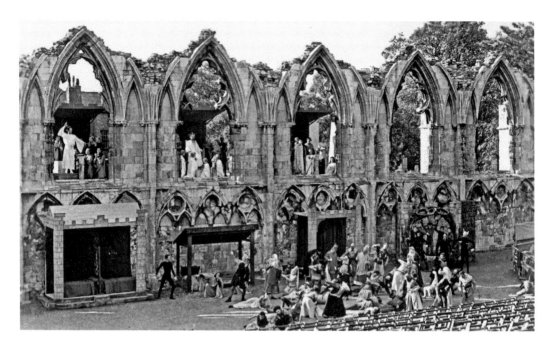

St Mary's Abbey

One of the richest abbeys in the country at the time, St Mary's Abbey was the largest and richest Benedictine establishment in the north of England and one of the largest landholders in Yorkshire. The Benedictines had completed the abbey in 1088 for Abbot Stephen and a group of monks from Whitby; it was financed by the Anglo-Breton magnate Alan Rufus, (Alan the Red, *c*. 1040–1093), 1st Lord of Richmond, relative to and friend of William the Conqueror and William II. The top card shows the devil appearing in a 1954 performance of the *Mystery Plays* in St Mary's Abbey, photographed by the late Will Acton.

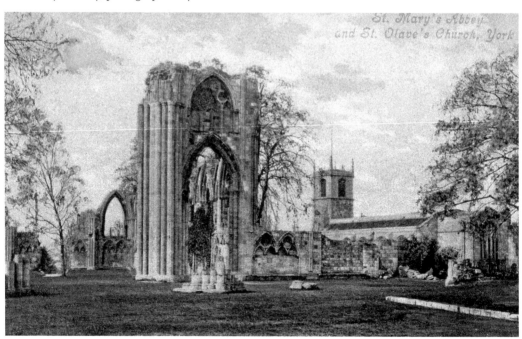

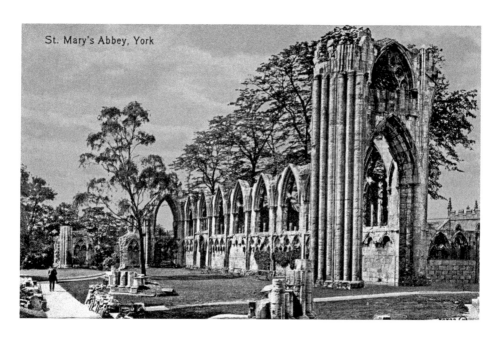

St. Mary's Abbey, York

York Mystery Plays

The official name of the York Mystery Plays is the York Corpus Christi Plays. They are essentially a Middle English cycle of forty-eight mystery plays, or pageants, which adumbrate religious history from the Creation to the Last Judgment. They were traditionally staged on the feast day of Corpus Christi (a movable feast on the Thursday after Trinity Sunday, between 23 May and 24 June). At York, the plays were produced from the mid-fourteenth century until 1569 and are one of only four surviving English mystery play cycles. The others are the Chester Mystery Plays, the Towneley/Wakefield Plays and N-Town Plays. The devil again tempting Christ in 1954 is on the lower card.

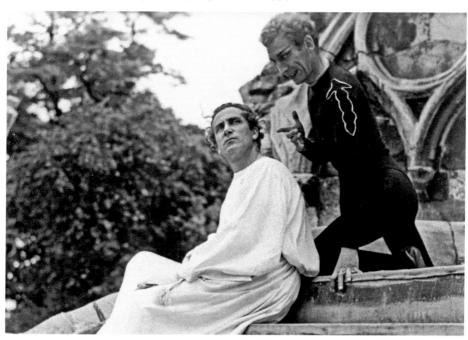

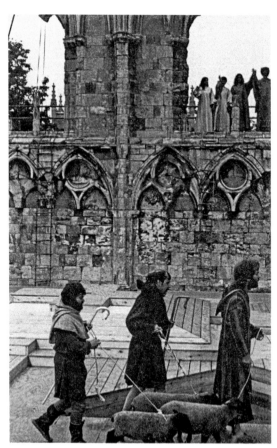

The York Pageant
The three shepherds with lambs in the 1980 production. In 1909, the York Pageant was a dramatisation of York's history in seven episodes from 800 BCE to 1644 CE. With a cast of 2,500, the epic production involved 800 costume designs by forty different artists, and 2,000 tracings were made and coloured; the chorus comprised 220 singers. In 1971, the pageant showed more recent events from York's history. Here we have an arrogant Dick Turpin, who was hanged at York for horse stealing in 1739.

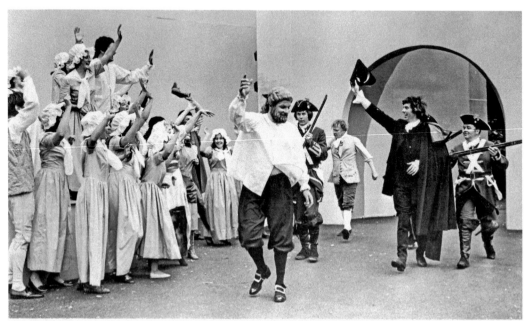

2. DICK TURPIN UNDER ARREST ENTERS YORK
Pageant of York 1971

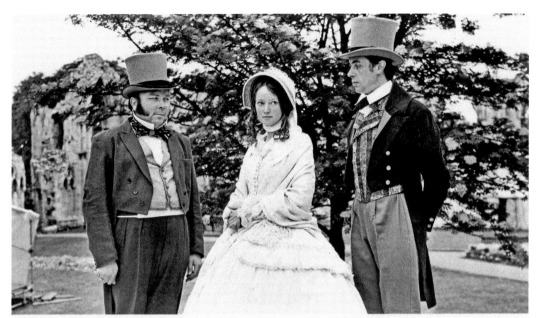

6. QUEEN VICTORIA & PRINCE ALBERT MEET
GEORGE HUDSON, THE RAILWAY KING
Pageant of York 1971

George Hudson and Joseph Rowntree

York has been a major UK railway centre since 1839 when the first trains came and went from the city. Its future as a hub was ensured when the wily George Hudson – the 'Railway King' – convinced a compliant George Stephenson, apparently, to 'mak all t'railways cum t' York'. Here, he is beguiling Queen Victoria and Prince Albert – little could they know what was on the horizon. Joseph Rowntree, announcing the new Haxby Road chocolate factory, is the subject of the lower card.

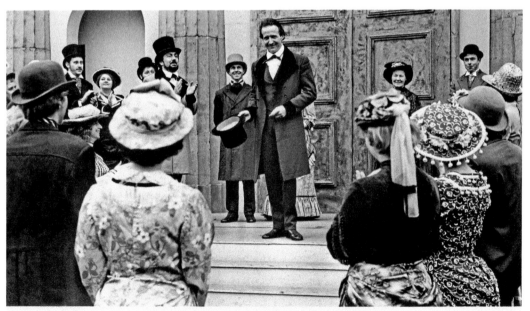

4. JOSEPH ROWNTREE ANNOUNCING HIS NEW FACTORY
Pageant of York 1971

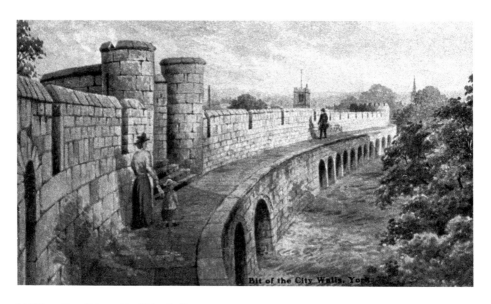

Bit of the City Walls, York

William Etty RA and Wilkie Collins

A lovely depiction of the city walls on the upper card. We have much to thank William Etty RA (1787–1849) for when it comes to the surviving walls, bars and buildings of York. His sonorous letter to the city's corporation vandals and philistines resonates to this day:

> Beware how you destroy your antiquities, guard them with religious care! They are what give you a decided character and superiority over other provincial cities. You have lost much, take care of what remains.

Around the same time, Wilkie Collins (1824–89), a frequent visitor to the city, set his 1862 novel *No Name* in York, describing a walk along the walls by Captain Wragge as 'one of the most striking scenes which England can show ... the majestic west front of York Minster soared over the city and caught the last brightest light of heaven on the summits of its lofty towers'.

The lower card shows workers laying electric tramlines through the walls in Station Avenue leading to George Hudson Street and Tanner's Moat in 1910. The walls had been punctured in the 1840s then formed into a single arch in 1966.

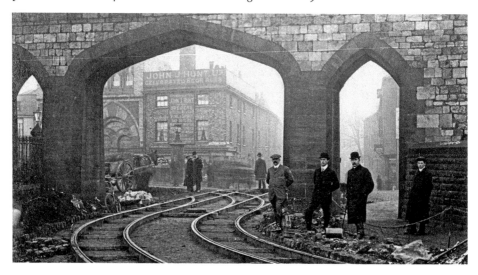

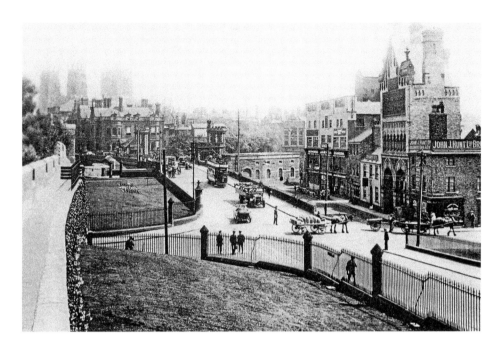

Lendal Bridge and Botterill's Repository for Horses

Lendal Bridge from the walls in 1920 complete with railings. In 1953, the John J. Hunt Ebor Brewery here was taken over by Cameron's of West Hartlepool. Next door, Botterill's Repository for Horses was built in 1884; it was reduced in height by a half in 1965 when it became a car dealers. Patrick Nuttgens described the original building as 'an exotic red and yellow Byzantine building with ramps inside, up which the horses were led to their stalls – a kind of multistorey horse car park'. It was frequently used by patrons of the 1868 Yorkshire Club for Gentlemen (River House) in from the country, just over Lendal Bridge. The 1955 Valentine card below is from a watercolour by EFC Parr from an original photograph, which makes it look rather like Toytown.

YORK FROM THE CITY WALLS. A 1948

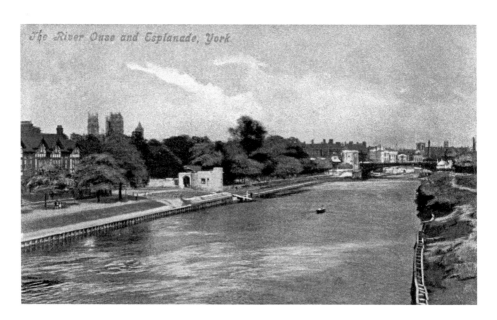

The Rivers Ouse and Foss and Marygate Landing

The walls were built in the thirteenth and fourteenth centuries on a rampart dating from the ninth and eleventh centuries. They survive for the best part of their two-miles-plus length, as do the four bars and thirty-seven internal towers. Four of the six posterns and nine other towers are lost or have been rebuilt. The walls for the most part are 6 feet wide and 13 feet high. They were breached in two places in the 1840s to allow access to York's second railway station and to a goods depot known as the Sack Warehouse.

The rivers Ouse and Foss have always been pivotal to York for reasons of trade, industry and, more recently, tourism. Both of these picturesque cards were posted in 1904, showing the Ouse at Clifton, and further downstream, with Lendal Bridge in the distance, the Marygate Landing on the left.

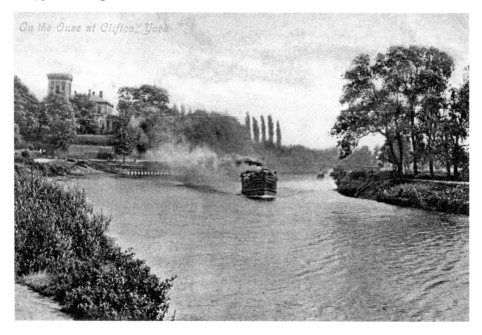

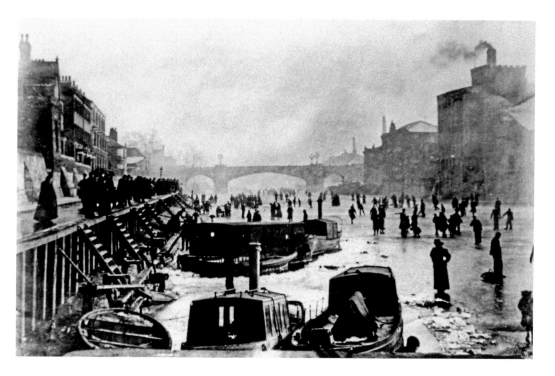

King's Staith

Before the railways came, York's trade depended on its rivers. The lower card shows the Ouse at King's Staith, busy with various ships. The King's Arms and (what is now) the Lowther can be seen on the opposite bank with Ouse Bridge in the centre. The upper picture is of a frozen Ouse with Terry's factory belching out smoke on the right. The ice was so thick that brazier's could be lit on it to roast chestnuts.

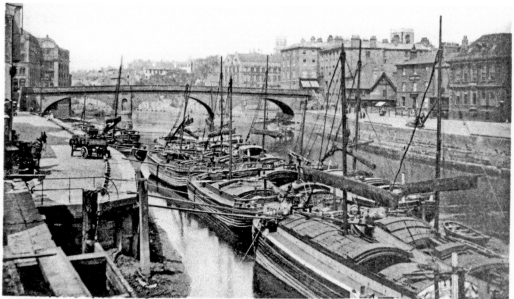

M4104 COLLECTOR-CANALS King's Staith, York c1903 Pamlin Prints
(Photo : Courtesy A.K.Robinson Esq., Dewsbury) Croydon CR0 1HW

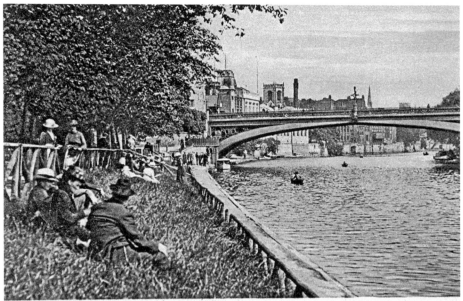

LENDAL BRIDGE & RIVER OUSE, YORK

Guildhall, Lendal Tower and Barker Tower

Relaxing on the banks of the Ouse with the Guildhall visible behind Lendal Bridge. The card beneath shows *View of the Ouse Near York*, an 1826 watercolour by Henry Gastineau (1792–1876). This is before Lendal Bridge was built and shows Lendal Tower on the left beyond Marygate Landing (left foreground). Barker Tower is 'out of shot' on the right. Uses over the years include a boom tower and a mortuary from 1879. The painting hangs in the City Art Gallery. (Image courtesy of York Museum Trust http://yorkmuseumstrust.org.uk/ Public Domain)

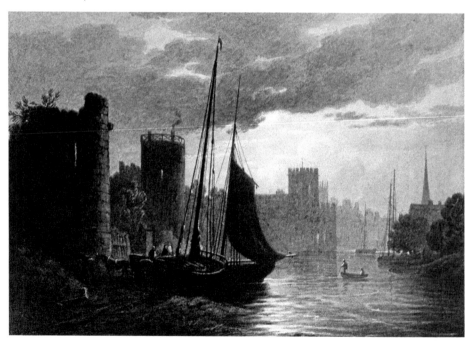

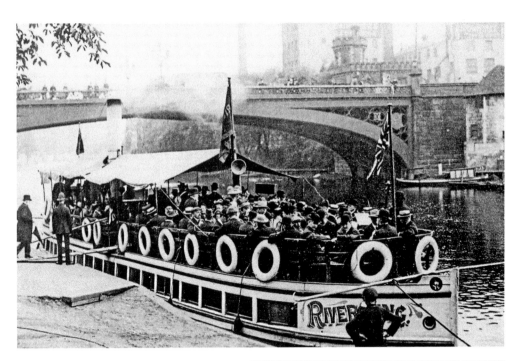

The *River King,* at Rowntree's Factory
and Marygate Landing

The River King boat trip on the Ouse
about to set sail in 1900, with Rowntree's
first factory at Tanner's Moat in the
background, to the right of Lendal Bridge.
The lower card shows the same boat on
the same river, but this time at Marygate
Landing. Built to answer the need for
access to the new railway, Lendal Bridge
was opened in 1863 to replace the ferry,
which plied between the Lendal and
Barker Towers. Jon Leeman was the last
ferryman – he received £15 and a horse
and cart in redundancy compensation.
The bridge was designed by the aptly
named William Dredge. Unfortunately,
his bridge collapsed during construction
killing five men; it was replaced by the
present bridge, designed by Thomas
Page, who was responsible also for
Skeldergate Bridge here and Westminster
Bridge. The remnants of Dredge's
bridge were dredged up from the river
and sold to Scarborough Council, who
used the rubble in the construction of
Valley Bridge.

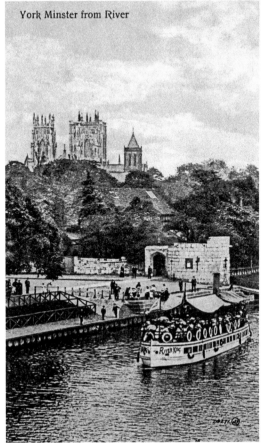

York Minster from River

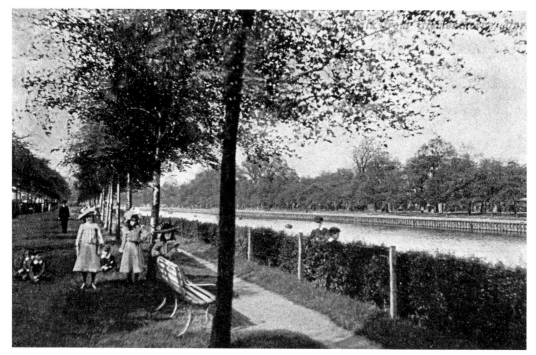

The New Walk

The New Walk along the Ouse was *the* place to perambulate from 1730 when it was built for Georgian York residents to enjoy a stroll by the river. In 1754, the *York Courant* reported in this most objective piece of journalism: 'This Terrace Walk ... may be justly esteemed one of the most agreeable publick walks in the Kingdom for its great neatness, beautiful town situation which is so advantageously seen in its prospect as to render it not unlike nor inferior to any of the views in Venice'. Barker Tower dates from the early fourteenth century. It was given a new roof in the seventeenth century and was restored in 1840, 1930 and 1970. The name derives from the barkers who stripped bark off oak trees to be used by tanners; hence nearby Tanner's Moat and Tanner Row.

OUSE AT LENDAL BRIDGE, WITH
NORTH STREET POSTERN TOWER, YORK

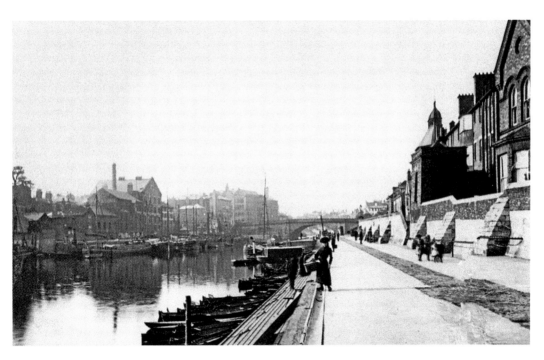

The Ouse, taken from Skeldergate Bridge and Rowntree's Wharf
A view of the Ouse taken from Skeldergate Bridge soon after it opened in 1881. Terry's is on the left and Ouse Bridge is in the distance. The lower image is of a barge loading at Rowntree's warehouse (Rowntree's Wharf) in what was formerly the grain warehouse at Leetham's Mill in Foss Islands just off the river.

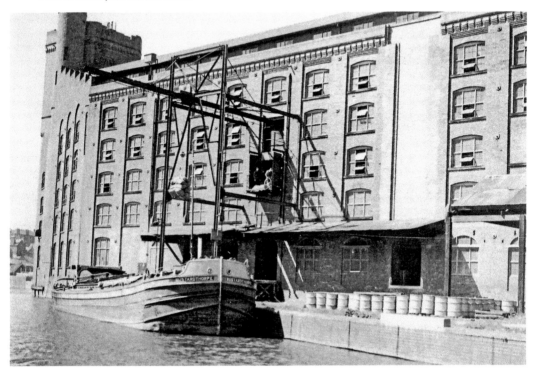

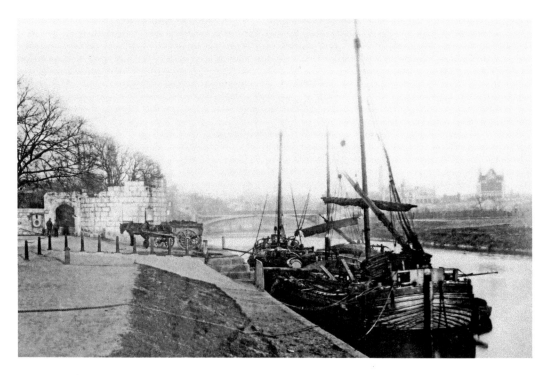

Barges on the River Ouse

A wonderful shot of a barge unloading coal at Marygate Landing onto a horse and cart for onward shipment. Lendal Bridge is in the distance with Rowntree's and Botterill's on the right in the haze. The lower card depicts a similar but very different scene: this is looking towards Skeldergate Bridge with Terry's on the left in Clementhorpe and the New Walk on the opposite bank.

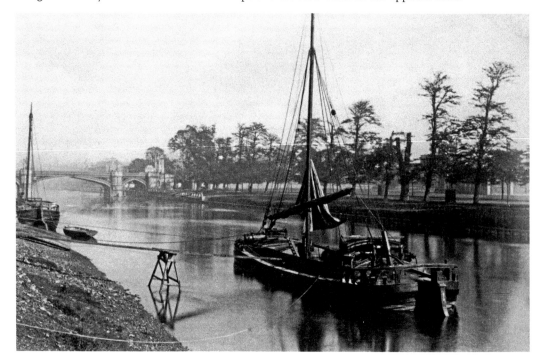

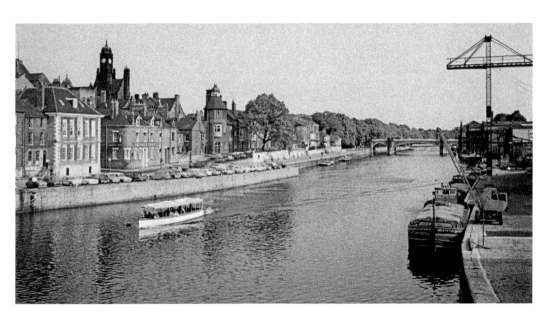

Ouse Bridge

Another two, more modern, cards showing the Ouse. The top one shows the river and a pleasure boat from Ouse Bridge, and the lower depicts a pleasure boat and Hotel Slab, the awful concrete abomination that was the Viking Hotel, which is now the Park Inn. Lendal Bridge is in the distance with the Guildhall on the right. Daniel Defoe, in his *Tour Through the Whole Island of Great Britain* dismissively described Ouse Bridge as 'near 70 foot in diameter; it is, without exception, the greatest in England, some say it's as large as the Rialto at Venice, though I think not'. There were about fifty shops, a prison or kidcote, a town hall and a hospital on the bridge and, from 1367, England's first public toilets are reputed to have opened here (issuing into the river): 'the place on Owsbridge callyd the pyssing howes'. Agnes Gretehede was paid 2s a year to keep them clean in 1544. The present Ouse Bridge was built between 1810 and 1821.

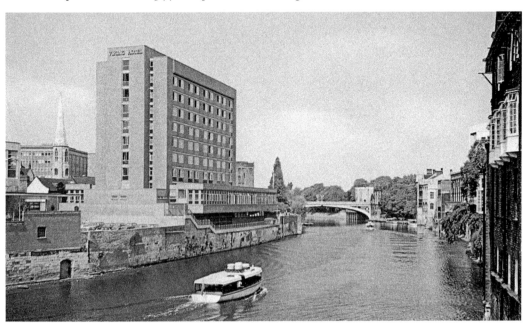

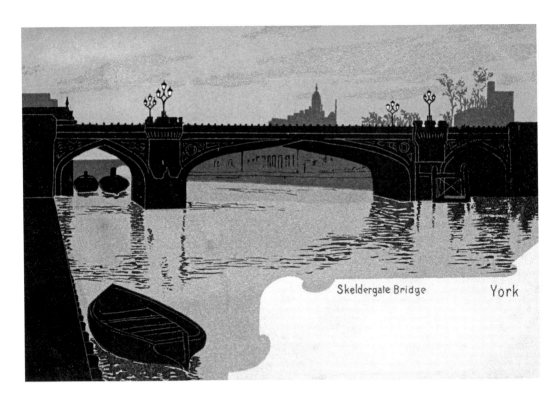

Seldergate Bridge

Seldergate Bridge was the third of the bridges over the Ouse to be built, in 1881. The fine silvered and gilded card shows what looks like Montmartre in the background but is really the law courts in Clifford Street. The castle can be seen in the lower card.

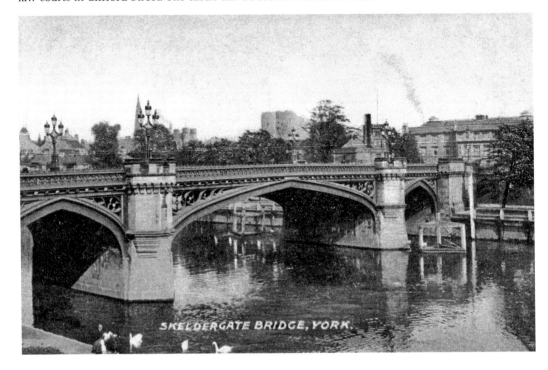

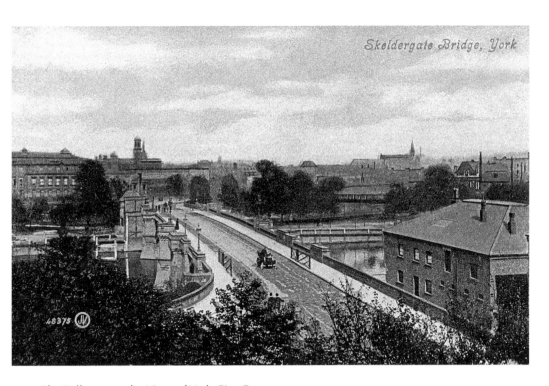

48375

The Tollgates and a View of York City Centre

The tollgates are visible on this picture. The lower image gives us a splendid view of York city centre with Lendal Bridge dominating in a scene from Railway Street to the minster.

JOHN J. HUNT. L? BREWERS, WINE & SPIRIT IMPORTERS

— YORK from N.E.R. OFFICES —

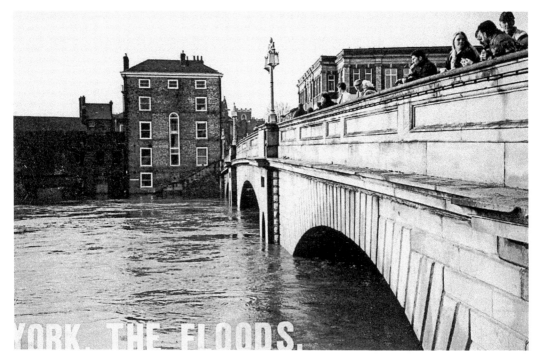

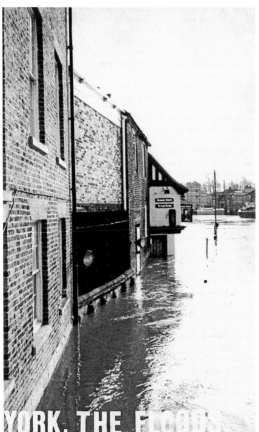

Floods

Floods are, of course, a perennial feature of York life and here we have the annual spectacle under Lendal Bridge and Ouse Bridge with 'the pub that floods', the pub that is never dry, the King's Arms on the left. On the right-hand side of the door as you go in is a board with the flood levels marked on it. During Christmas and New Year 2015–2016, the Ouse peaked at 5.2 metres above its normal summer level when the Foss Barrier and the Environment Agency failed the city, with waters flooding the city and an inestimable cost to the local economy.

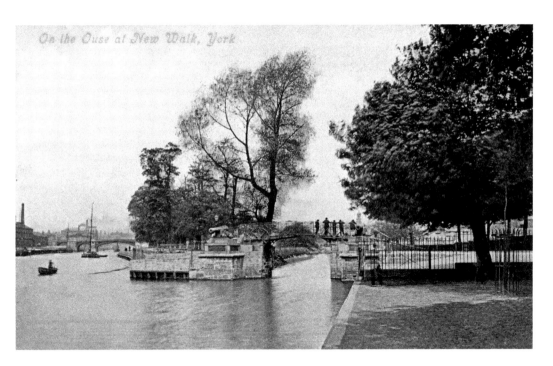

On the Ouse at New Walk, York

Blue Bridge

Blue Bridge is at the confluence of the Foss and Ouse. A succession of bridges spanned the Ouse here, the fourth of which can be seen here flanked by two Russian cannon presented to the city in 1858 after the 1855 Siege of Sebastopol. They were sold for scrap in 1941 as part of the war effort. The present Blue Bridge, the latest of five, all blue, was built in 1930 on the site of the original 1730 wooden blue bridge.

On the Foss.

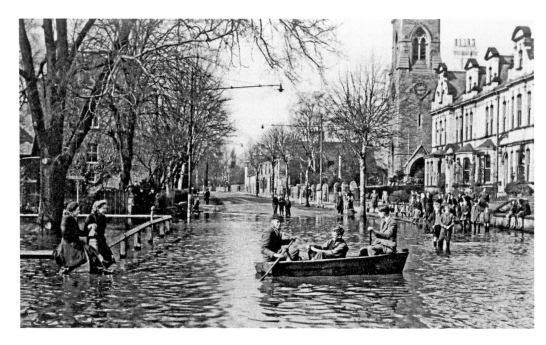

Yearsley Road Swimming Baths and the Water End Floods

The swimming pool here was simply a stretch of the River Foss where the riverbed was concreted over. The tendency for young boys to swim naked there deterred most females. The city of York benefitted from Joseph Rowntree's sense of civic responsibility and philanthropy when in 1909 the Yearsley Road swimming baths next to the Haxby Road factory were gifted to the people of York. The upper card shows boys from St Peter's in a chivalrous rescue attempt during the Water End Floods in Clifton in the 1920s.

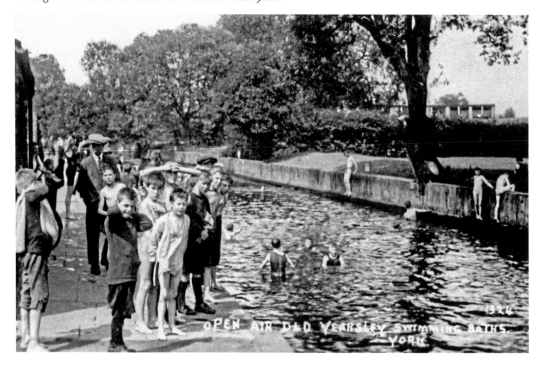

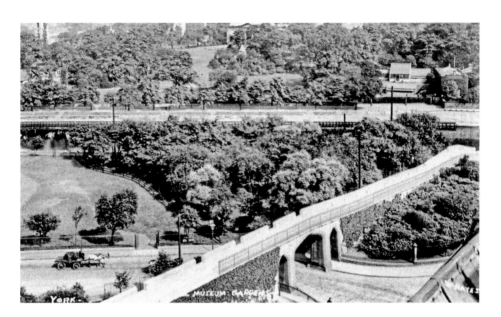

Museum Gardens and Rowntree Park

A splendid shot of Museum Gardens. The gardens were designed in the 'Gardenesque' style by landscape architect Sir John Murray Naysmith in the 1830s in 4 acres formerly known as Manor Shore. As more and more exotic specimens were introduced, a conservatory was built to house tropical plants such as sugar cane, coffee, tea, ginger and cotton, as well as orchids and epiphytes. A pond was created to accommodate a large, rare water lily, the Victoria Amazonica. Although the pond and the conservatory are long gone, the 10-acre gardens are still a listed botanical garden and contain many varieties of trees, deciduous and evergreen, native and exotic. From 1835 until 1961, an entrance fee was charged. York Swimming Bath Company's pool opened here in 1837; it was closed in 1922 and, in 1969, it was filled in. Rowntree Park was given to York by Joseph Rowntree in 1921 at the end of the First World War as a memorial to the company's staff who lost their lives or suffered during the war. The park was York's first municipal park. A set of gates were added in memory of those who fell during the Second World War.

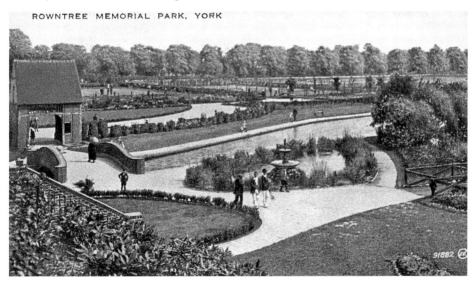

31

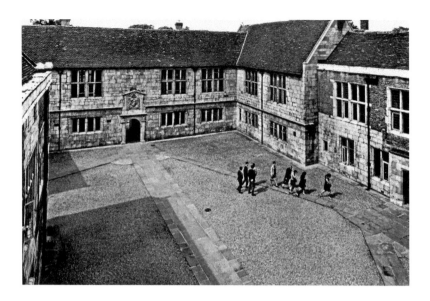

King's Manor

The magnificent, often-overlooked King's Manor off Exhibition Square in 1907, was originally built in 1270 as the house of the abbot at St Mary's Abbey. It was rebuilt in 1480, the new windows providing the earliest-known examples of the use of terracotta as a building material. In 1561, after the Dissolution, the lord president of the Northern Council took possession. Visitors included Henry VIII and James I and during the siege of York in 1644, it was the Royalists' headquarters. The ornate doorway with the stunning coat of arms at the main entrance is Jacobean and the 'IR' stands for James I, who ordered the manor be converted into a royal palace for him to stay in on trips to and from London and Edinburgh. Charles I added the magnificent royal arms, celebrating the Stuarts. After a long period of private lettings and decay, Mr Lumley's Boarding School for Ladies occupied it from 1712–1835 and then the William Wilberforce-inspired Yorkshire School for the Blind moved in during 1833 and, from the 1870s, gradually restored and enlarged the buildings, adding a gymnasium and a cloister to create a second courtyard. The Blind School left in 1958; the manor was then acquired by York City Council, who leased it to the University of York in 1963, as in the upper card.

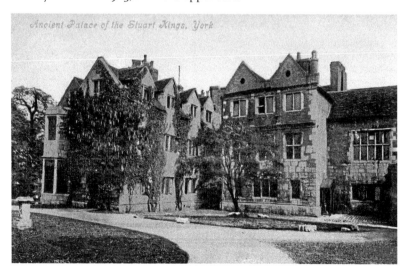

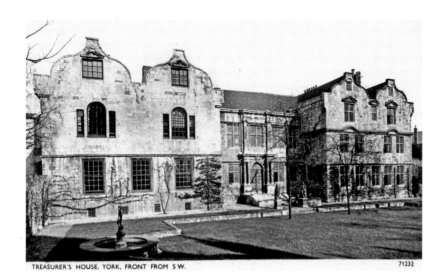

TREASURER'S HOUSE, YORK, FRONT FROM S W. 71232

The Guildhall and The Treasurer's House

The Guildhall was built in 1445 on the site of the earlier 'Common Hall', dating from at least 1256. It was originally for the Guild of St Christopher and St George and the Corporation, who took over completely in 1549. Council meetings are still held there in the Victorian Council Chamber of 1891. It was used as a theatre – Richard III watched *Credo* here in 1483 – and as a court of justice, and was where Margaret Clitherow was tried in 1586. In 1647, during the Civil War, Cromwell agreed to pay a ransom of £200,000 to the Scots in exchange for Charles I; the money was counted here. The Guildhall contains a bell captured at the Siege of Rangoon in 1851. It was badly damaged in the Baedeker Raid of 1942 but was fully restored in 1960. The subterranean Common Hall Lane passes under the Guildhall (then called Common Hall) to a jetty on the river, originally a continuation of Stonegate.

The present building of the Treasurer's House combines a rebuild from around 1300 and a Grade I-listed Jacobean town house with distinctive Flemish gables. Each room is laid out in the style of a different period, as instructed by the eccentric Frank Green who donated it, complete with contents, to the National Trust. The Parliamentarian general, Sir Thomas Fairfax, of Marston Moor fame, once owned it. By the nineteenth century, though, it was reduced to 'a bug-ridden slum'.

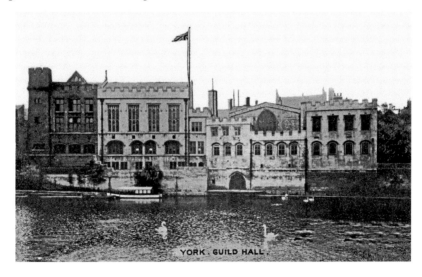

YORK . GUILD HALL .

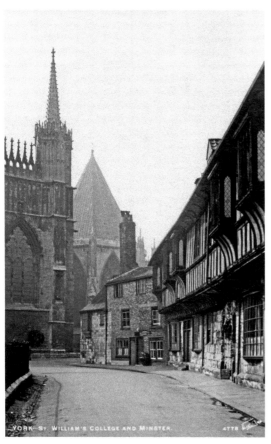

St Williams' College I

Originally the House of the Prior of Hexham, St Williams' College is named after Archbishop William Fitzherbert (St William), Archbishop of York from 1143–47, and built in 1465 by order of Warwick 'the Kingmaker'. The college was home to the Minster's Chantry, twenty-four priests and their provost, who received advance payments for praying for the souls of their deceased benefactors. The fellows' behaviour often left much to be desired; alcoholic intoxication and brawling were often involved. To curtail this embarrassment, the then archbishop of York decided to monitor the priests' behaviour more closely by building for them their exclusive residence, St Williams' College.

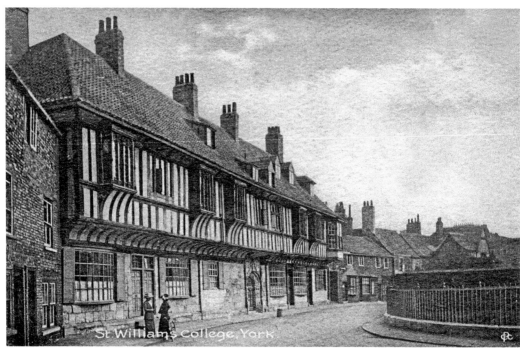

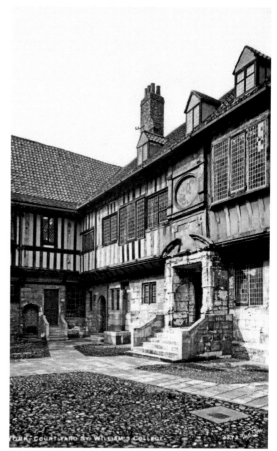

St Williams' College II

William was canonised in 1226. He
was the nephew of King Stephen
and great-grandson of William the
Conqueror. In 1642, Charles I set up his
printing press in Sir Henry Jenkins'
house in St Williams' College. The royal
presses rolled from March to August
that year and turned out seventy-four
documents including Charles' *Counsell
of Warre*. The lower card depicts the
college yard when the timbers were
covered over.

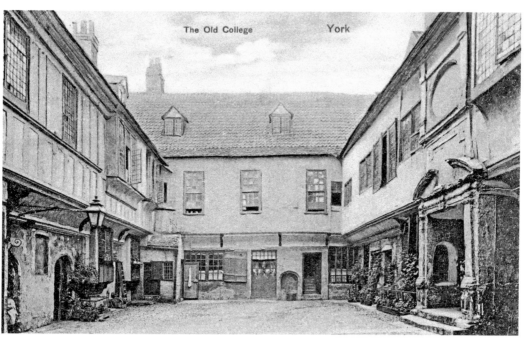

The Old College York

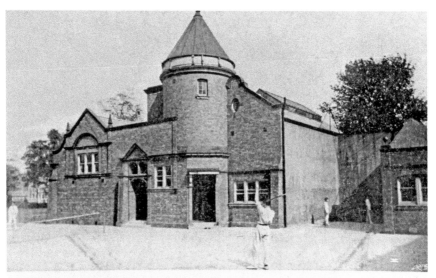

Elliott & Fry. BOOTHAM SCHOOL, YORK The Science School. London, W.

Quaker Bootham School and Merchant Adventurers' Hall

Quaker Bootham School was moved to Roman Catholic Ampleforth during the Second World War; Donald Gray, the head at the time, is reputed to have addressed the combined school as 'Friends, Romans and Countrymen'. Bootham was not the only boys' Quaker School in York. In 1827, the Hope Street British School was established and attended by many children of 'Friends'. It was slightly unusual because, in addition to the usual curriculum, it taught the working of the electric telegraph with the Electric Telegraph Company supplying the instruments and the school reciprocating by supplying the company with clerks. The Merchant Adventurers' Guild goes back to 1357 when a number of prominent York men and women joined together to form a religious fraternity and to build the Merchant Adventurers' Hall, as depicted on the lower card in 1905. By 1430, most members were merchants of one kind or another. They then set up a trading association or guild using the great hall to conduct their business affairs and to meet socially, to look after the poor in the almshouses in the Undercroft and to worship in the chapel.

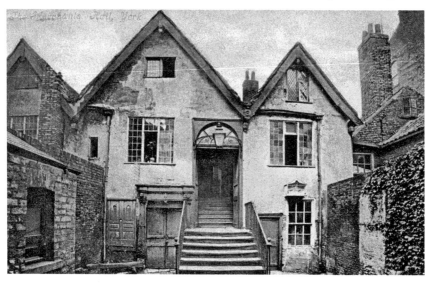

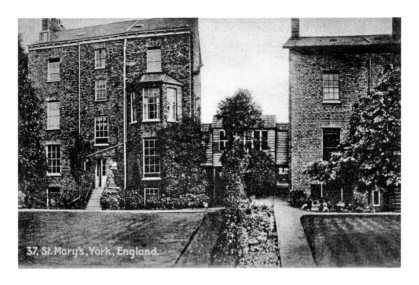

37, St. Mary's, York, England.

Joseph Rowntree and Guy Fawkes

The good and the bad of York are encapsulated on this page. In 1855 Joseph Rowntree Snr built Penn House, or 'Top House', with its distinctive, ionic columns on an orchard on the corner of Bootham and St Mary's (number 38). In the 1870s, Joseph Rowntree Jr moved to a house at the bottom of St Mary's but the family soon moved back up the street to settle next door to Top House, as pictured here. Rowntree & Co. later sold Top House to Bootham School for £2,000. Guy Fawkes was born just off Low Petergate, was baptised at St Michael-le-Belfrey and was a pupil at St Peter's. As Capt. Guido Fawkes, he had a distinguished military record, and his expertise with explosives led the plotters to recruit him in their attempt to assassinate James I. Guy Fawkes, calling himself Johnson, a servant to Thomas Percy, smuggled thirty-six barrels of gunpowder under the House of Lords, ready for its royal opening on 5 November 1605. Just before midnight he was arrested, 'booted and spurred', ready to make his getaway, having on his person a watch, lantern, tinderbox and slow fuses. He was interviewed by James I in his bedchamber, taken to the Tower of London to be tortured, and finally 'hanged, drawn and quartered' as a traitor on 31 January 1606. Though he is still burnt in effigy on 5 November ('Plot Night' as it is called in parts of Yorkshire), no Guy is ever burnt at St Peter's.

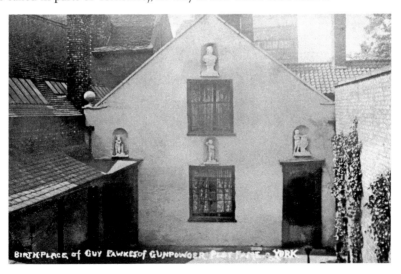

BIRTHPLACE of GUY FAWKES of GUNPOWDER PLOT FAME, YORK.

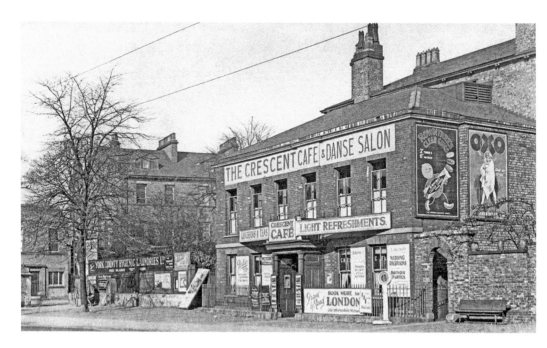

The City Roller Skating Palace and the Crescent Café and Danse Salon.
The City Roller Skating Palace and the Crescent Café and Danse Salon. The former became the City Picture Palace cinema by the start of the First World War. The Odeon cinema was built on the site of the latter in 1937, which had opened in 1925, typical of Oscar Deutsch's art deco 'palaces for the people'. They were intended to evoke luxury liners and to exude luxury in contrast to the ordinariness found back in most pre-war homes. A Union Jack Flag flew from the roof whenever a British film was showing. Odeon derives from 'Oscar Deutsch Entertains our Nation?' Not a bit of it: the Odeons were named after the Ancient Greek for a building used for a musical performance.

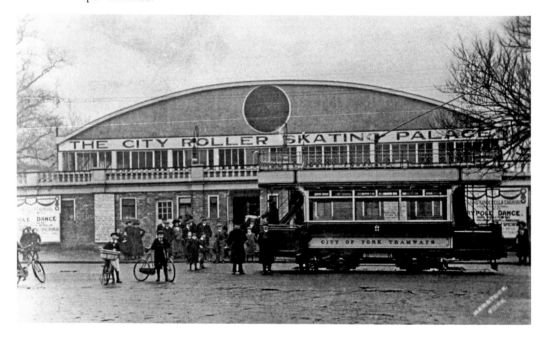

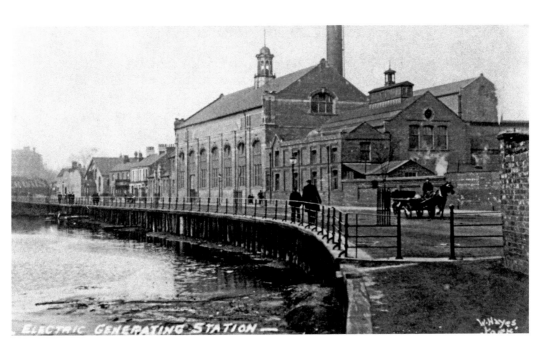

ELECTRIC GENERATING STATION —

W.Hayes
York.

Holgate Mill
A 1904 William Hayes card showing the earth-shaking electricity generating station in Foss Islands Road looking towards Layerhorpe Bridge. The imposing 1770 five-sail Holgate Mill is built on the site of a fifteenth-century predecessor. At that time, Holgate was a village with a population of fifty-five. Unusually, the mill had five double-shuttered sails; they were damaged in a 1930 storm and taken down after the mill was powered by an electric motor. The Holgate Windmill Preservation Society looks after the mill today and completed a marvellous reconstruction in 2012.

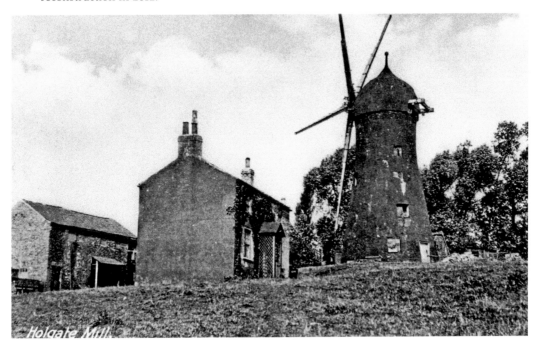

Holgate Mill

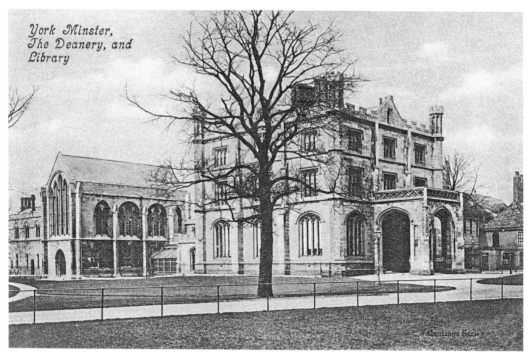

York Minster, The Deanery, and Library

YORKSHIRE WAR MEMORIAL, YORK.

The Deanery and the Boer War Memorial

The Deanery or Old Palace (pictured here in 1952) not only houses York Minster's library and archives but also the collections department and the conservation studio. It is known as the Old Palace because part of the building used to be the chapel of the thirteenth-century archbishop's palace. In 1810, it was refurbished and, shortly after, the minster's collection was installed there. The original Old Deanery was demolished in 1831 on its site where the Minster Song School now stands. In 1640, Charles I convened a Great Council of Peers of the Realm here over a number of weeks, the buildings decked out especially for the occasion. In 1789, the future George IV and the Duke of York, his brother, dined here. The Boer War Memorial in Duncombe Place in 1906 is on the lower card; unveiled in 1905, it records the 1,490 York citizens who lost their lives, including two female nurses, in combat and through rampant disease.

The City Art Gallery and the Hospitium

The Italianate building that now houses the City Art Gallery opened its doors to the public in 1879 and in 1892 became the City Art Gallery. The original building had a 'Great Exhibition Hall' at the rear with room for 2,000 people. This was a venue for boxing and cock fighting as well as exhibitions; it was damaged by bombs during the Second World War and demolished in 1942. The gallery's collection was initiated in 1882 when a retired horse dealer from Poppleton, John Burn, was persuaded to leave his collection of paintings to the city rather than to his first choice, the National Gallery. Apart from numerous paintings of York and its buildings, there are many works here by William Etty. Every year between 1950 and 1962 an artist was paid £50 to produce a picture of York; L. S. Lowry's painting of Clifford's Tower is one of the results. The Hospitium is a fine fourteenth-century half-timbered building in Museum Gardens, probably designed both as a guesthouse for visitors to St Mary's Abbey opposite and as a warehouse for goods unloaded from the adjacent river for the abbey.

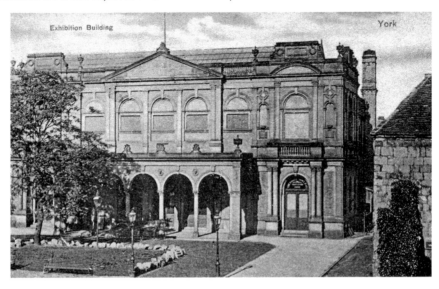

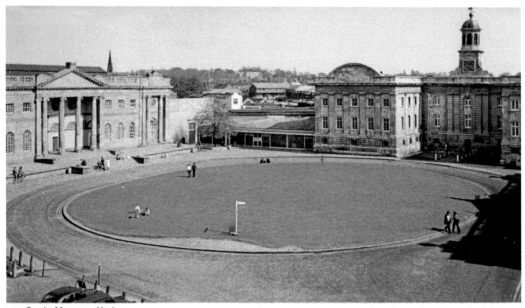

Castle Museum, York Y.0233

The Castle Museum

The entrance to the Castle Museum is a low-level modern construction, but it extends into the buildings on either side including, on the left, the former prison. The buildings here make up the 'Eye of the Ridings'. York Castle Museum opened in 1938 and is one of Britain's leading museums of everyday life. It is famous for its Victorian street, Kirkgate, named after the museum's founder, Dr John Lamplugh Kirk, a Pickering doctor who collected everyday objects, his 'bygones', and for whom the museum was converted from the Women's Prison as somewhere to keep them safe for future generations. The 140-bed York Youth Hostel in Clifton is pictured on the lower card.

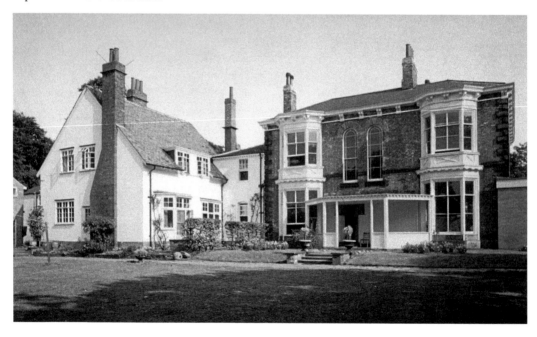

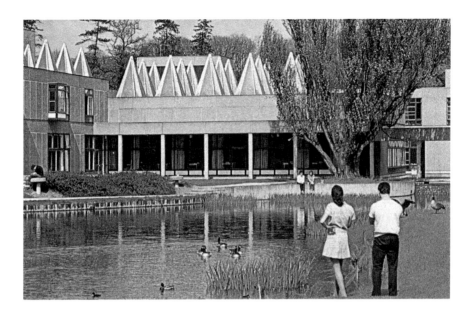

University of York

Derwent College on the famous lake and Heslington Hall are the subject of these two cards featuring the University of York. The first petition for a university in York was to James I in 1617 followed by other unsuccessful attempts in the eighteenth century, one to annex it to the existing, short-lived, medical school. In 1903, F. J. Munby and others (including the Yorkshire Philosophical Society) proposed a 'Victoria University of Yorkshire'. The College of Ripon and York St John considered purchasing Heslington Hall as part of a proposed new campus. The campus lake is the largest plastic-bottomed lake in Europe and attracts many waterfowl. The campus also supports a large rabbit population, the hunting of which by students is strictly prohibited. Heslington Hall is a fine Elizabethan manor built by Thomas Eymes in 1568; Eymes was secretary to Henry VIII's Great Council of the North, which had its headquarters in King's Manor. As with other buildings of the time, it was constructed in the shape of an 'E' in honour of Elizabeth I.

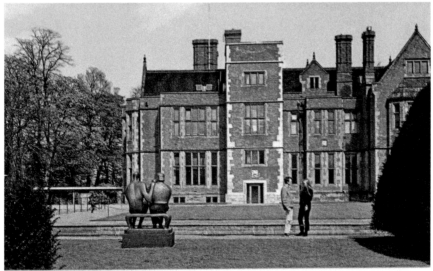

Hestlington Hall, York University. U1B

43

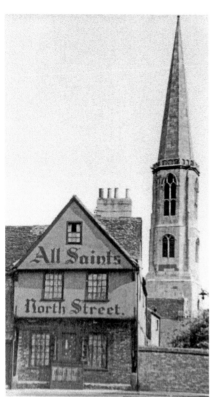

All Saints Church and St Crux Church

When it comes to churches, York is blessed with some truly magnificent examples, many of which can be counted among the best in the land. One of these is All Saints in North Street, which comprises early English, decorated and perpendicular styles and features an octagonal tower with an unusual 120-foot spire. Emma Raughton, a visionary anchorite, lived in an anchor hold here – a two-storey house attached to the aisle. The church has some of the finest medieval stained glass in Europe that is not actually in York Minster, including the aisle window that shows the Six Corporal Acts of Mercy (as in *Matthew*) and the famous 1410 Doom Window (or 'Pricke of Conscience' window), which graphically depicts your last fifteen days before the Day of Judgement. One of the most heinous acts of Victorian civic vandalism to be visited on a city (and there have been many) was the dynamiting of the cupola-topped St Crux in Pavement in 1887 on spurious health and safety grounds. More happily, some of the church's treasures can still be seen in the parish hall, which was built from the rubble, not least the beautiful 1610 monuments to Sir Robert and Lady Margaret Watter.

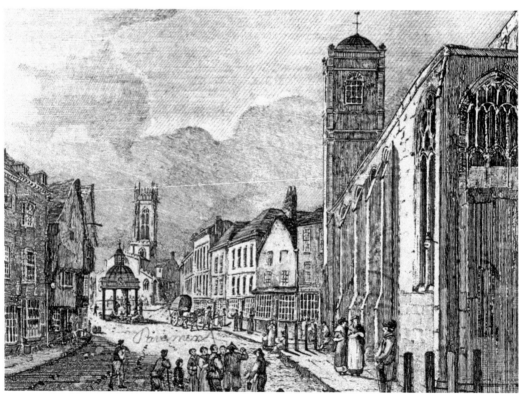

Holy Trinity Church

The Roman Porta Principalis Sinistra, King's Square, was home to Holy Trinity Church before it was demolished in 1935. It was traditionally the Butcher's Church on account of its proximity to the Shambles. A projecting chapel known as Langton's Chantry was York's first fire station. The lower card illustrated how accusations of cruelty towards horses led to the publication of a series of comic postcards mocking the York Tramway Company. Horse-drawn trams were not welcomed by all. In their introduction in 1878 a certain D. K. Clark probably spoke for many when he declared: 'the employment of horsepower in the dire work of starting and dragging the ponderous cars in vogue is an element of barbarism, germane, it may be, to the primitive habits of oriental life, but very much out of place in a civilised country'. St Martin-cum-Gregory is in the background; now redundant, it has been home to the superb Stained Glass Centre since 2008.

THE HILLY BIT OF OLD YORK.

Margaret Clitherow Oratory and the Bar Convent

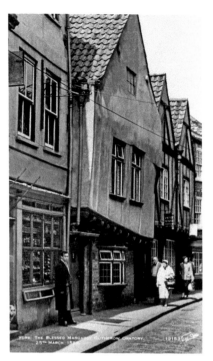

This Walter Scott card shows the Margaret Clitherow Oratory in the Shambles. Margaret was found guilty in 1586 of 'harbouring and maintaining Jesuits and priests, enemies to Her Majesty'. The usual penalty was hanging, but, because she refused to offer a plea at her trial at the city assizes in the Guildhall (called Common Hall at the time), she was sentenced to be pressed to death by Sir John Clenche (*peine forte et dure*) by having a door weighted with nearly half a ton of boulders placed on top of her, at the tollbooth on Ouse Bridge. Within fifteen painful minutes, she was dead. Elizabeth I wrote to the citizens of York in horror at the treatment meted out to a fellow woman. Margaret was beatified in 1929 and canonised in 1970 by Pope Paul VI who described her as the 'Pearl of York'. Her embalmed hand is in the Bar Convent; a church in Haxby is dedicated to her. The Bar Convent is the oldest lived-in convent in England. During the Baedeker air raid in 1942, the Bar Convent School was hit and collapsed, killing five nuns including the headmistress, Mother Vincent.

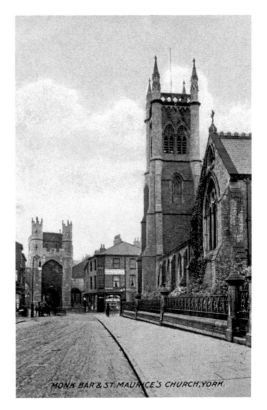

MONK BAR & ST MAURICE'S CHURCH, YORK.

St Maurice's Church and St Martin-le-Grand

St Maurice's Church with Monk Bar in the background. The first church here, on the corner of Monkgate and Lord Mayor's Walk, was demolished in 1875 to make way for a larger one, pictured here, itself pulled down in 1967 when Lord Mayor's Walk was widened to improve traffic flow around the walls. The lower card is of St Martin-le-Grand in Coney Street. The largely fifteenth-century church still functions as a church but is also now a moving shrine to all those who lost their lives in the World Wars. The sextant-wielding 'Little Admiral' from the 1778 clock was bombed to the ground during the Baedeker Raid but luckily found by Eric Milner White, Dean of York, and kept until the restoration of the clock in 1966.

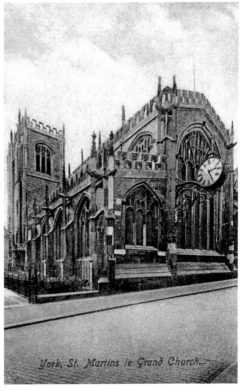

York, St. Martins le Grand Church.

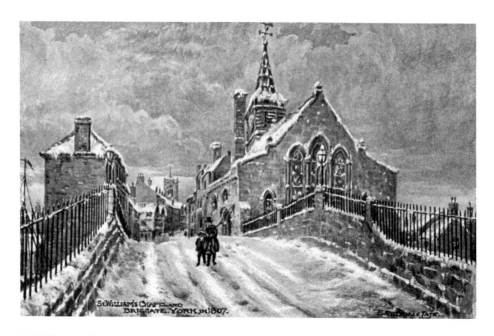

St William's Chapel and Il Duomo

Old Ouse Bridge is York's Ponte Vecchio. Demolished with the old Ouse Bridge in 1809, the thirteenth-century St William's Chapel was at the south end of the bridge. The chapel was dedicated to St William of York in 1228, who had returned to York from exile in Sicily after his reinstatement. The crowds on the bridge to welcome him were so huge that the bridge collapsed under their weight. On seeing the calamity unfold, William made the sign of the cross; no one died (one horse suffered a broken leg) and the event was immediately declared a miracle. The chapel and the canonisation of William Fitzherbert was partly a response by York to compete with Thomas Becket in Canterbury, with a saint and a shrine of their own. The relative size of the minster is often compared with Milan, Chartres and other mighty cathedrals. Here is a card showing Il Duomo in Milan.

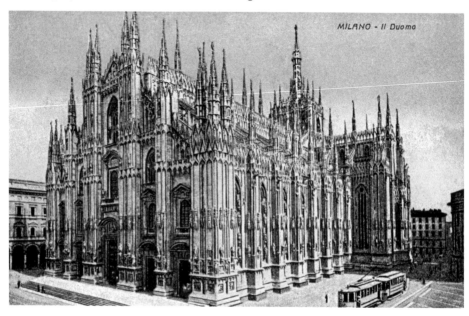

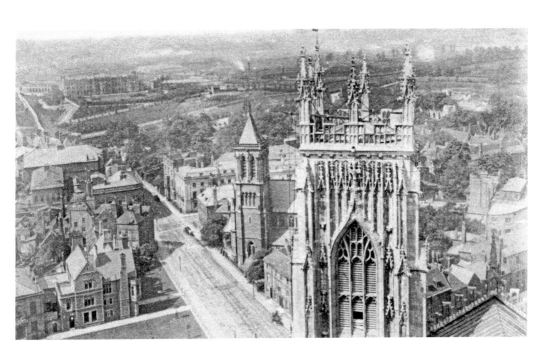

York Minster I

Two wonderful cards that show York Minster in all its glory. The lower is a view from Museum Street in 1853 showing Lop Lane in front of the minster and demolished to make way for Duncombe Place. The one above is taken from the central tower in 1890, clearly showing the newly created Duncombe Place with St Wilfrid's Catholic Church. The Royal Station Hotel is in the distance to the right of the station.

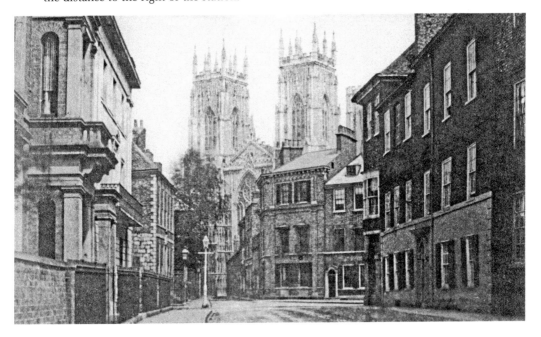

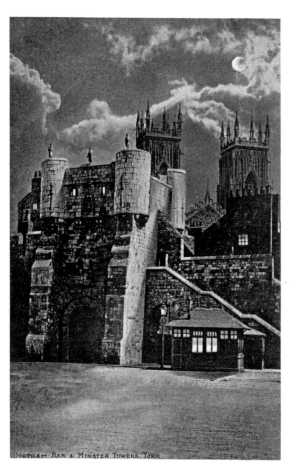

BOOTHAM BAR & MINSTER TOWERS, YORK.

York Minster II

The Minster by moonlight from Exhibition Square with Bootham Bar, and the Minster from St Sampson's Square with the Three Cranes pub, the Golden Lion and what later was called the Roman Bath in the centre on the corner. The sign on the Three Cranes pub in the square is designed to mislead; the pub is named after the lifting gear used by stallholders rather than anything ornithological. The Roman Bath was formerly The Mail Coach, The Barrel Churn, The Cooper and The Barrel. The Roman bathhouse excavated under the Roman Bath in 1930 is partly visible, including a cold room, *frigidarium*; a hot room, *caldarium;* and underfloor central heating system, *hypocaust.* Tiles stamped *Legio VI* and *Legio IX* have been uncovered, recording which legions were stationed at Eboracum.

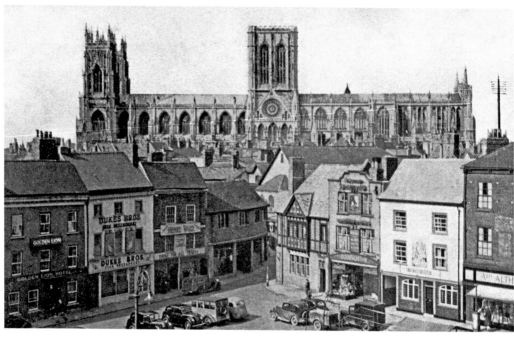

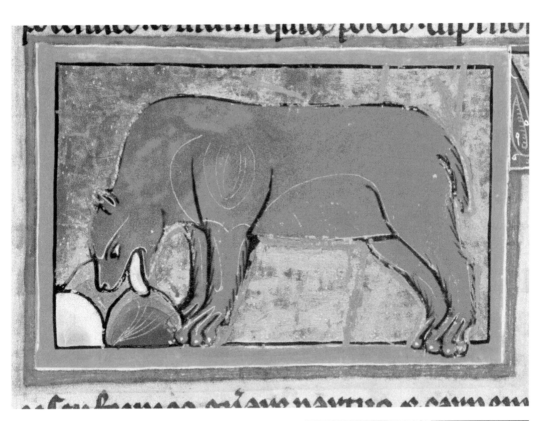

Holy Trinity, Micklegate and All Saints, Pavement

Holy Trinity, Micklegate, has an ongoing interactive exhibition on the monastic life of the priory entitled 'Monks of Micklegate'. Extensive research included work at St John's College Oxford on a marvelous bestiary, an 800-page book of beasts with ninety beautifully coloured illustrations depicting Christian virtues as displayed by God's creation and made by the monks of Holy Trinity. This card shows one of these: the female bear lived for three months underground after giving birth to formless lumps of flesh; she then licked them into the shape of cubs, from which we get our phrase 'licking into shape'. From the *Holy Trinity Bestiary (MS61)* reproduced by permission of the president and fellows of St John's College, Oxford.

In July 2015, a very special event took place in All Saints, Pavement; the unveiling of the Afghanistan 2001–2014 window in which three fallen soldiers from York are commemorated along with the many other York citizens who served there including Marine David Hart, Trooper Ashley David Smith and Lance Bombardier Matthew Hatton.

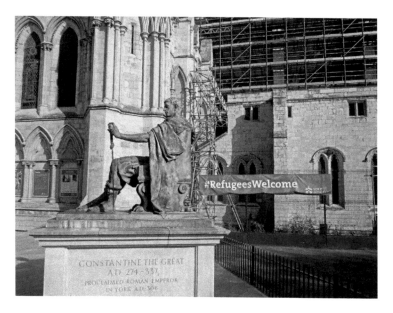

The Statue of Constantine

Roman Emperor Constantine welcoming refugees at the minster in 2005, in the true Roman spirit of inclusiveness and engaging with the rest of Europe. Perhaps there was a lesson to be learnt there. The statue celebrates his proclamation as emperor here in 306 CE on the death of his father, the Emperor Constantius Chlorus in York, and his conversion to Christianity, probably in 312. Septimius Severus, Rome's first black emperor, lived in York between 208 and 211; his sons, Caracalla and Geta, were declared co-emperors in 198 and 209. Severus died in York in 211 and received a spectacular funeral in the city but not before he had declared York to be the capital of Britannia Inferior. Hadrian visited too. The lower card is of a British Railways travel poster celebrating the York Mystery Plays produced by Edward Bawden in 1954.

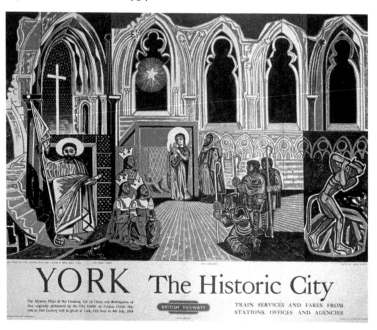

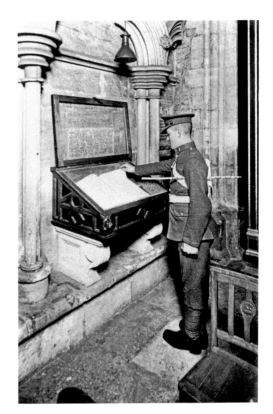

Roll of Honour, York Minister
A private of the West Yorkshire Regiment
(Prince of Wales Own) turning a page in the
Roll of Honour in St George's Chapel in the
minster in 1925. A page is turned every day.
The colour card shows choristers processing
through the choir.

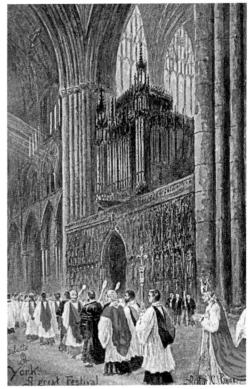

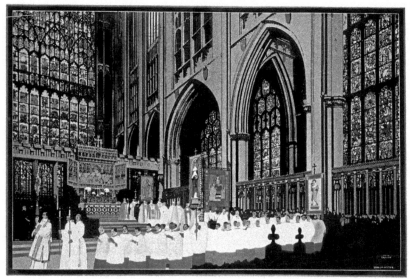

YORK MINSTER
IT'S QUICKER BY RAIL
FULL INFORMATION FROM ANY L N E R OFFICE OR AGENCY

Choristers

More choristers: the top card shows a service portrayed on a LNER card by Fred Taylor promoting the ecclesiastical attractions of York; the lower shows choristers in the Minster's undercroft. The beautifully illustrated *York Gospels* was brought to the minster in 1020. It is used as the oath book for all incoming archbishops and minster clergy and is on display in the undercroft of the minster. In addition to the four gospels, it contains the oaths taken by the deans and canons, documents about land ownership and the letter of King Cnut (r. 1016–1035). The book was produced in Canterbury around 1000 and came to York with Archbishop Wulfstan around 1020. It is one of only ten pre-conquest Gospel books to have survived the Reformation.

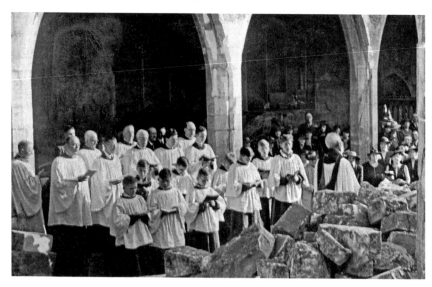

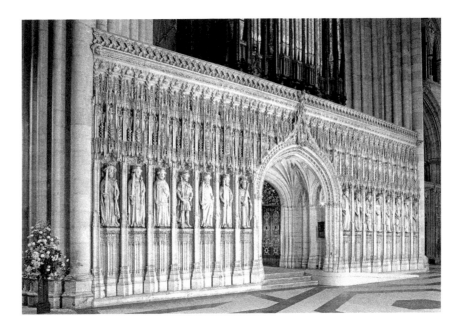

York Minster's Choir Screen and Stained-glass Windows

Here are two more cards that are stunning. The upper depicts the marvellous choir screen with the fifteen kings of England from William I to Henry VI. Fred Taylor's LNER 1923 celebration of the minster's stained glass is the subject of the lower card. 60 per cent of all England's medieval stained glass is in York Minster; 128 medieval windows 'light' the building. The Great East Window is the single largest medieval stained-glass window in the country. The minster has 2 million pieces of glass.

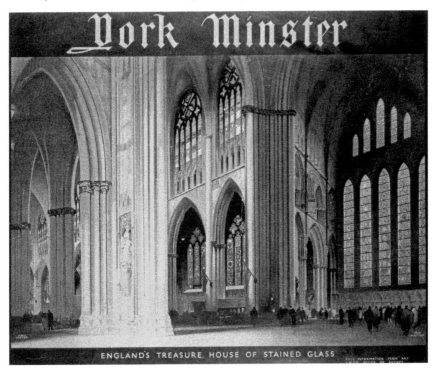

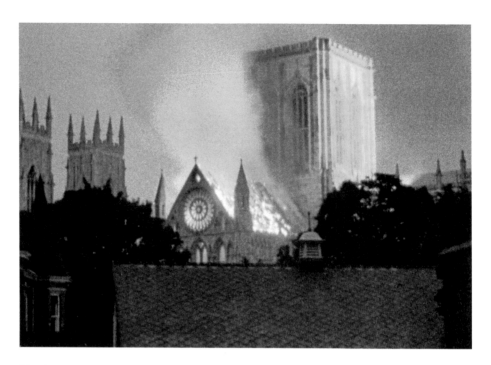

Fire in 1984

The last major fire, depicted here, was in 1984. UFOs and divine retribution were soon ruled out, an improvident lightning strike given as the most likely cause. Whatever the cause, the south transept roof was destroyed and the beautiful rose window shattered. Four years later the painstaking repairs were completed, including bosses in the south transept vaulting designed by winners of a *Blue Peter* competition.

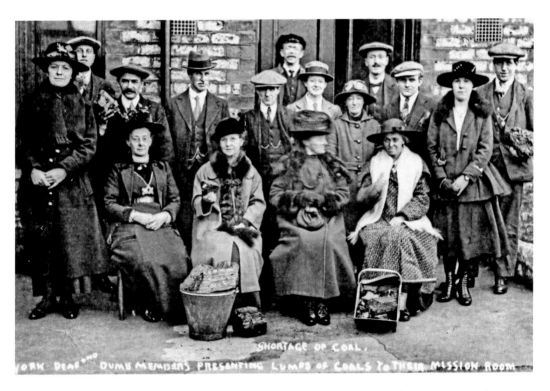

York & District Christian Mission to the Deaf and Dumb and a Rugby League Match

The upper card shows proud members of the York & District Christian Mission to the Deaf and Dumb donating coal in the 1920s. Beneath we have a card showing York vs Dewsbury in a rugby league match at Clarence Street (where the car park is now) in 1923.

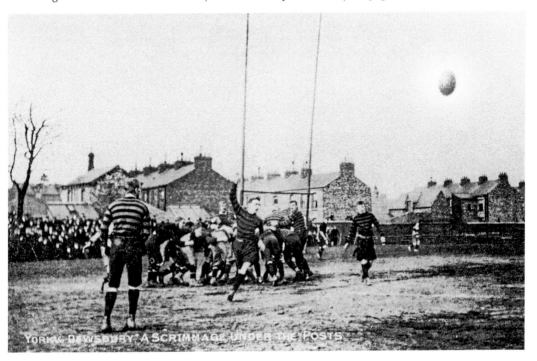

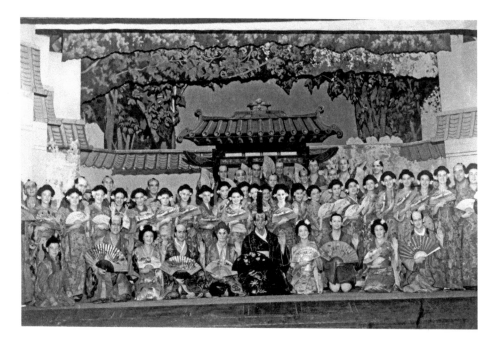

The Folk Hall, New Earswick

The cast of *The Mikado* at the Folk Hall, New Earswick, in 1953 in all their costumed glory. The Folk Hall was and is the nucleus of the village; it was built in 1907 at a cost of £2278 15s 1½d. Rowntree actively encouraged women to get out of the home and to use the many facilities offered there: 'In this country it seems to be the thought that women do not need recreation,' he pondered, citing the example of Germany where it was, and still is, the norm for families to go out together as families, with the children. During the First World War the hall was used to accommodate Belgian refugees who reciprocated by giving French lessons to local residents. A fund was set up for 1d per head to support the refugees, described as 'innocent sufferers of Prussian brutality' and nine houses were hastily furnished and provided rent-free for nine families. The lower card shows Rowntree's workers outside their new dining hall on Haxby Road.

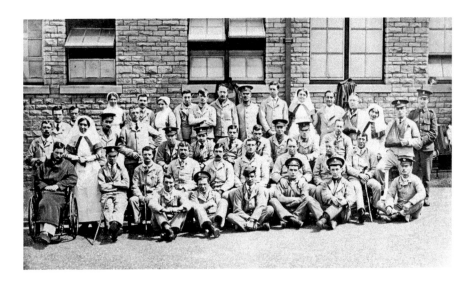

The Hospital in Haxby Road and the 9th British Esperanto Congress

It was during the First World War that the dining hall was requisitioned for use as a hospital. A group of casualties are shown here. Before that, it was requisitioned as billets for the 1,000 or so men of the 8th Battalion, the West Yorkshire Regiment (Territorials); in 1915 the Leeds Rifles came and went, to be replaced by men of the King's Own Yorkshire Light Infantry. In the lower card, we see the massed ranks of delegates at the 9th British Esperanto Congress outside the minster in 1916. Esperanto ('one who hopes') is the most widely spoken constructed language in the world. Its name comes from Doktoro Esperanto the pseudonym under which physician and linguist L. L. Zamenhof published the first book detailing Esperanto, the *Unua Libro,* in 1887. Zamenhof's aim was 'to create an easy-to-learn, politically neutral language that would transcend nationality and foster peace and international understanding between people with different languages'. Up to 2 million people worldwide actively speak Esperanto, including 1,000 native speakers who learned Esperanto from birth.

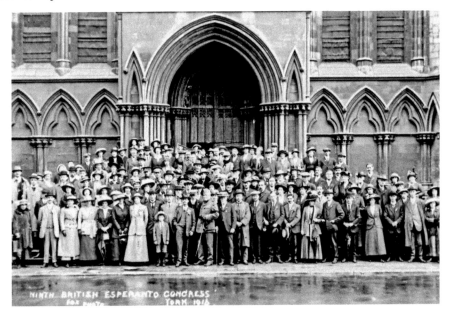

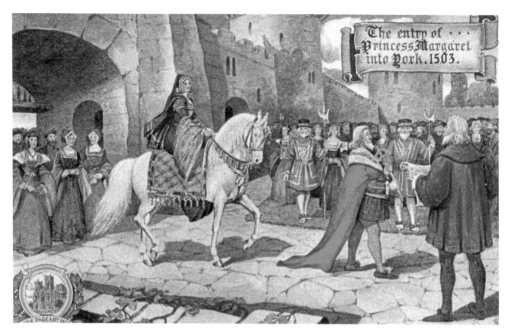

The entry of Princess Margaret into York. 1503.

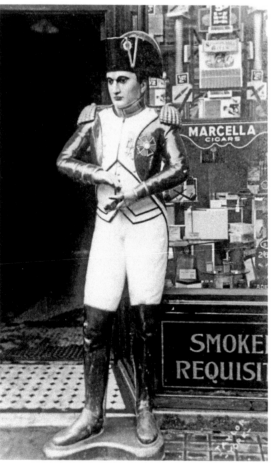

Princess Margaret and Napoleon

Margaret Tudor, dowager queen of Scotland, visited York in 1503 and again in 1516 and 1517 on her way to and from a visit to her brother, Henry VIII. She stayed at St Mary's Abbey on both occasions. In 1503, she was met by two sheriffs of York and 100 citizens on horseback, along with the city's great and good. At Micklegate Bar the mayor, recorder and alderman met her in their finery, as depicted here. St Margaret's Arch, in the walls opposite Bootham Bar, is named after Princess Margaret but was built for her father, Henry VII.

The statue of Napoleon arrived in York in 1822, one year after his death on St Helena. He stood sentinel outside a tobacconists in Low Ousegate, H. Clarke, to whom letters were addressed simply as 'Napoleon, York' – and would arrive. In full uniform, he is proffering a snuffbox to passers-by and is carved out of a solid piece of oak and was one of three made, selling for £50.00 each. Apparently he frequently ended up floundering in the River Ouse, assisted there by soldiers garrisoned in York.

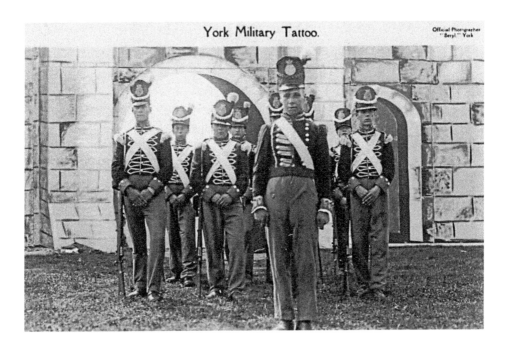

Official Photographer
"Beryl." York

York Military Tattoo and The George Hotel
Soldiers performing in York Military Tattoo on the Knavesmire, probably in 1929 – one of a series of such events that took place between 1914 and 1938. The other card shows party time during the races in 1908 at The George Hotel. The George was one of York's coaching inns serving Hull, Manchester and Newcastle in Coney Street, opposite the Black Swan and the *York Courant*, until 1869 when the inn was tragically knocked down to make way for Leak & Thorp. In 1867, it was called Winn's George Hotel. There was an earlier inn on the site called The Bull; the landlord, Thomas Kaye, replaced this with The George in 1614. Famous guests included Anne and Charlotte Brontë in May 1849. They shopped and visited the minster en route to Scarborough. Four days later Anne died of consumption aged twenty-nine.

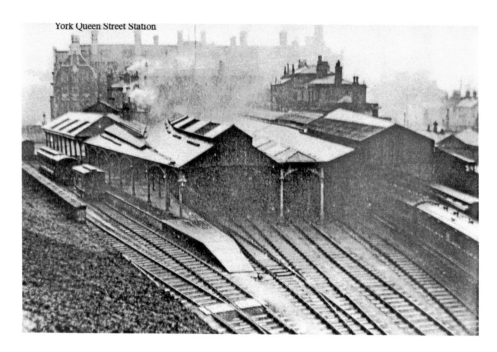

York Queen Street Station

Railway Stations

York has had three railway stations. The first was a temporary wooden building on Queen Street outside the walls, opened in 1839 by the York & North Midland Railway. It was replaced in 1841, on Tanner Row within the walls, by what is now called the York old railway station (in the lower card) and was built by Robert Stephenson on land owned by Lady Hewley's charity almshouses. River House is in the distance under construction. Access was difficult from North Street, and this eventually led to the construction of Hudson Street (after George Hudson), and Lendal Bridge. Because through trains between London and Newcastle were compelled to reverse out of George Hudson's York old station in order to continue their journey, a new station was built outside the walls. This is the present station, which opened in 1877.

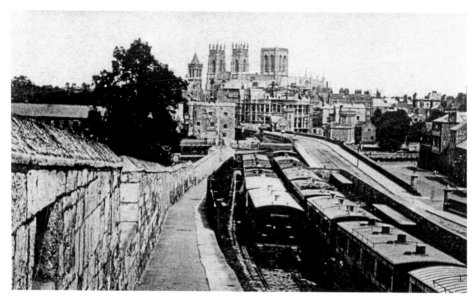

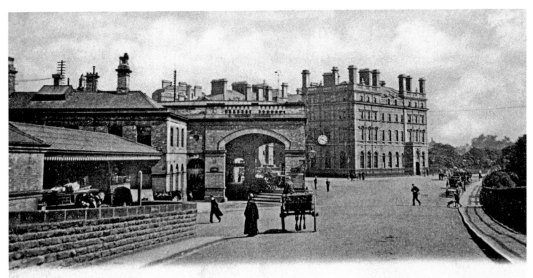

YORK STATION & HOTEL.

York's Station Hotels

The current station originally had thirteen platforms and was at that time the largest station in the world. At 800 feet long and 234 feet wide, this is one of the most spectacular examples of railway architecture in the world, rightly and famously described as: 'A splendid monument of extravagance', and 'York's propylaeum'. As part of the new station project, the Royal Station Hotel (now The Royal York Hotel), designed by Peachey, opened in 1878.

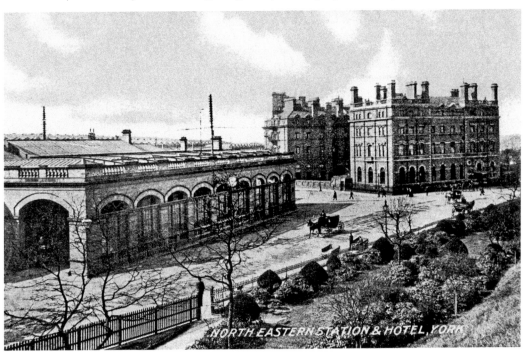

NORTH EASTERN STATION & HOTEL, YORK.

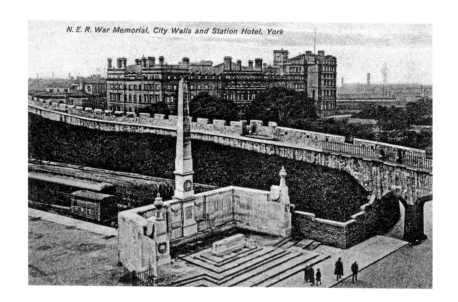

N. E. R. War Memorial, City Walls and Station Hotel, York

NER First World War Obelisk Memorial and National Railway Museum

Sir Edward Lutyens (he of the Whitehall cenotaph) was commissioned to design the NER First World War obelisk memorial, which stands outside the former NER offices and is shown on this 1926 card; the budget was £20,000. After much deliberation and controversy, the 54-foot-high Portland stone memorial was finally unveiled in June 1924, the inordinate delay caused by the dithering of the York Corporation agonising over the view from the (Lendal) bridge. Six thousand people attended the unveiling. The 15-foot-high screen walls (these had to be reduced in height) bear the names of the 2,236 men who died.

By the 1930s, all the railway companies had railway-related collections; these were all combined in 1948 after nationalisation. Under the terms of the 1968 Transport Act, a National Railway Museum was established to house the expanding collection, which was then housed in the British Transport Museum, Clapham, and in the existing York Railway Museum at Queens Street. In 1975, the celebrated National Railway Museum opened at Leeman Road in York.

York Station

In 1854, when Victoria, Albert and five of their children stopped off at York for a meal (a meal that was never eaten) on the way to Balmoral, there were local complaints about the expense of such a short visit – £483 13s 7d. Victoria got wind of the disquiet and so unamused was she that she never visited the city again in the remaining forty-seven years of her reign. The Visit York website takes up the story:

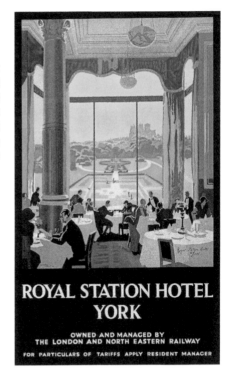

ROYAL STATION HOTEL YORK

OWNED AND MANAGED BY
THE LONDON AND NORTH EASTERN RAILWAY

FOR PARTICULARS OF TARIFFS APPLY RESIDENT MANAGER

> She had stated that this was a private visit, to be without ceremony. But the city council laid on a military display and erected stands for spectators; the Queen's temper was not improved when some of these collapsed and there was an unseemly scuffle. When the Queen eventually went to the Royal Station Hotel for her lunch, she was shocked to be presented with the bill to pay. She got up and said she would never visit York again, and never did. Whenever the Royal Train passed through York thereafter, she always made sure the blinds were firmly pulled down!

Delightful as it is, the story is a myth. Victoria had first visited the city as a princess in 1849. She passed through York eighteen more times, alighting from the train on ten occasions. The LNER poster card artist is Gordon Nicholl. One of the many excellent facilities boasted on the 1911 hotel lounge card is a typewriting room.

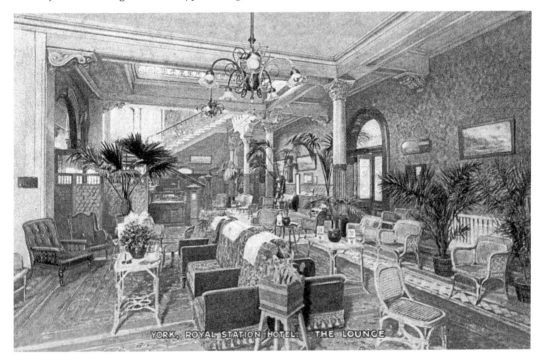

YORK, ROYAL STATION HOTEL. THE LOUNGE

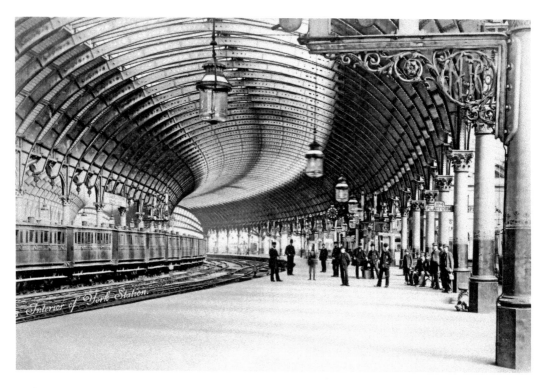

York Station

1907 was the year in which the colour card was sent, and the other shows the station with its magnificent roof in the 1890s. This spectacular glazed roof measures 800 feet by 234 feet, supported by imposing iron columns; the widest span covers platforms 8 and 9 and is 81 feet long; it is flanked by two 55-foot spans. 42 feet below, Its main platform is 1,692 feet long.

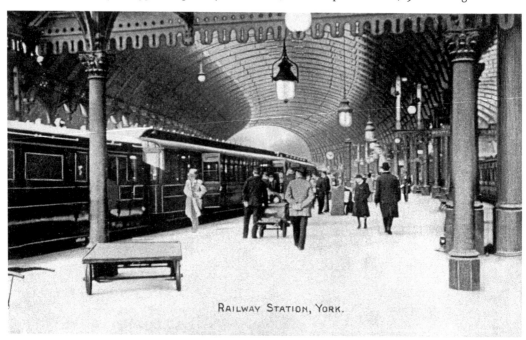

RAILWAY STATION, YORK.

Rowntree Train

Rowntree train at No. 1 Landing Stage in Wigginton Road in 1971. 4-6-2 Class A4 60019 Bittern 'streak' steams into York. Another example of this iconic locomotive, *Mallard,* is in the museum.

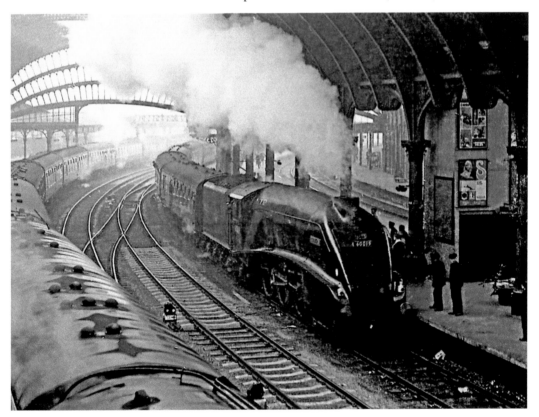

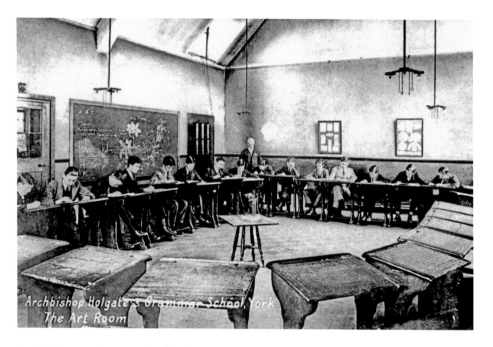

Archbishop Holgate's School and Bootham School

Even school classes could not escape the postcard mania. Archbishop Holgate's School is, after St Peter's, the oldest in York, and was founded as Archbishop Holgate's Grammar School in 1546 by Robert Holgate, financed by capital from the Dissolution of the Monasteries. In 1822, premises on Lawrence Street were leased from the Retreat, and Bootham School opened in early 1823 as the York Friends Boys' School, or 'The Appendage'. In 1829 it had become known as Yorkshire Quarterly Meeting Boys' School, its official name until 1889, even after it had moved to No. 20 (now No. 51) Bootham in 1846. It was the school's proximity to the River Foss that triggered the move to more salubrious premises, with one master even carrying a pistol to shoot the rats. Cholera was also a problem.

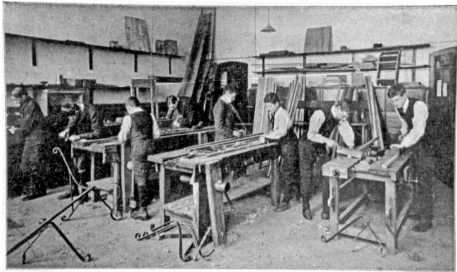

BOOTHAM SCHOOL, YORK. MAKING SEATS FOR THE CRICKET FIELD *Exhibited at the Franco-British Exhibition, 1908*

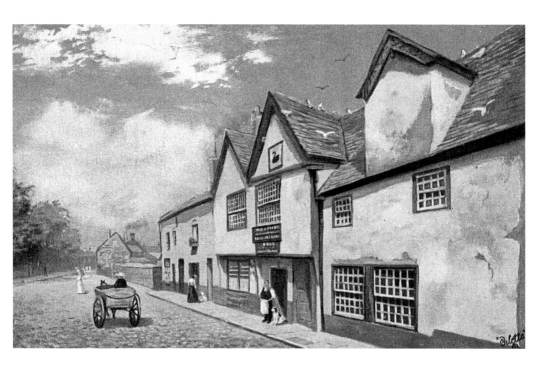

The Black Swan

Two cards showing the Black Swan in Peaseholme Green. The colour card was posted in 1907. The upstairs room was used for illegal cockfights; the grill used by a guard to watch the stairs can still be seen. General Wolfe, of Quebec fame, lived here in 1726; it was the HQ of the York Layerthorpe Cycling Club from 1834. The Leeds Arms (closed 1935) was next door on the corner of Haymarket and the Woolpack was over the road.

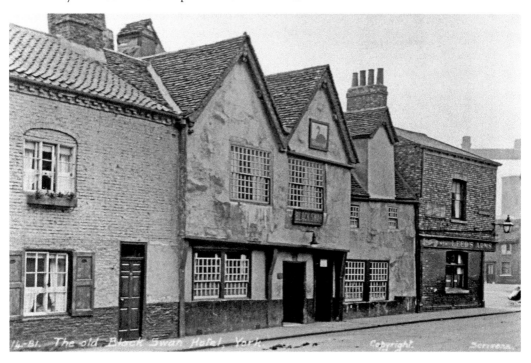

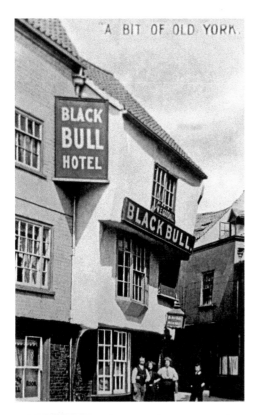

A BIT OF OLD YORK.

The Black Bull
The Black Bull off St Sampson's Square on
Finkle Street. The black-and-white card is
from 1906.

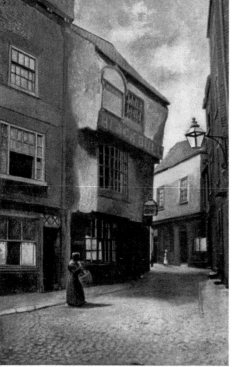

THE OLD "BLACK BULL," YORK.

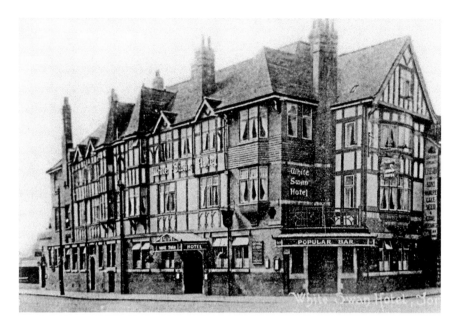

The White Swan Hotel and Harker's Bar

The White Swan Hotel on the corner of Piccadilly in its heyday. Until recently, the White Swan laid empty (and had been since 1982) and dilapidated for many a long year but it has now been refurbished and reopened as eighteen apartments. Dating from 1912, it is on the site of an older White Swan Hotel, which faced onto Pavement, but this was demolished to create Piccadilly and a through road to Fishergate. In 2003, squatters occupied the hotel, did it up and renamed it the Rainbow Peace Hotel. Built on the site of The York Tavern in 1770, Harker's was named after a butler who had worked at The Tavern. It was pulled down in 1928 so that St Helen's Square could be widened; it used to be triangular. Harker's then decamped to Dringhouses. The name lives on in the square though and Harker's Bar now occupies the grand Yorkshire Insurance Company building, which opened in 1924. The York Tavern was a coaching house with room for 150 horses.

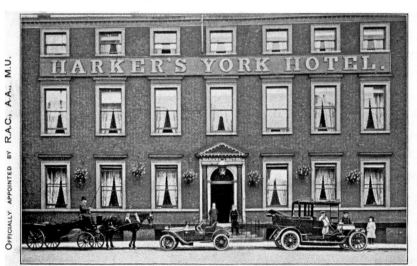

HARKER'S HOTEL, YORK.
NEAR MINSTER, ST. MARY'S ABBEY AND THEATRE.

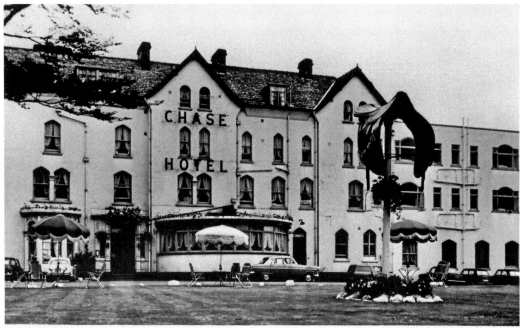

A VIEWCARD THE CHASE HOTEL, YORK

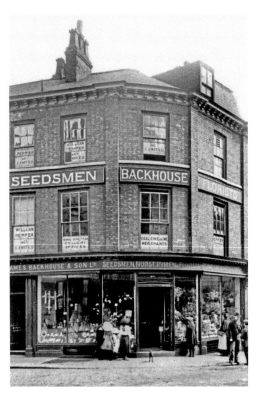

The Chase Hotel and J. Backhouse & Son Ltd
The Chase Hotel was famous for the enormous saddle at the front, indicating that it was near to the Knavesmire. J. Backhouse & Son Ltd, Nurserymen, was an early day, state-of-the-art garden centre in Fishergate with 'branches' in Acomb, Poppleton Road and Toft Green. The Backhouses bought the gardens of George Telford, another celebrated gardener, who, according to Francis Drake in *Eboracum*, was 'one of the first that brought our northern gentry into the method of planting all kinds of forest trees, for use and ornament'. James and his brother Thomas were nationally celebrated nurserymen and their gardens were collectively called the Kew of the North. They were responsible for the cultivation of numerous rare plants, some of which James brought back from South Africa and Australasia. A particularly striking feature was a 25-feet-high Alpine gorge built with 400 tons of rock, which led to a surge in rockeries all over the country. Backhouse had been producing catalogues long before 1821 when the second edition of their pithily titled *Catalogue of Fruit & Forest Trees, Evergreen & Deciduous Shrubs, Ornamental Annual, Biennial Plants, also of Culinary, Officinal & Agricultural Plants* was published.

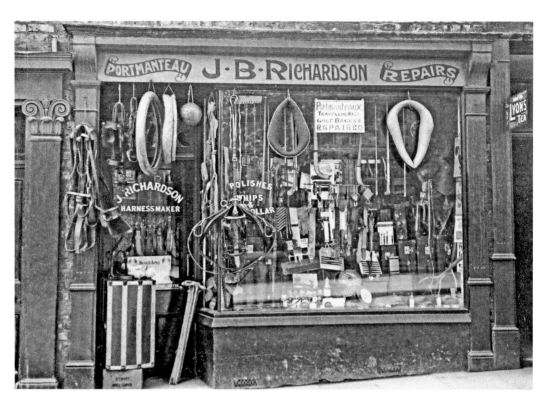

Richardson's, Lord Mayor's Way
A wonderful card showing Richardson's shop window display in Lord Mayor's Walk in 1913. The premises were later to become Bulmer's for many years until they closed in 2015. There are pianos and organs upstairs, and vegetables downstairs in this shop on the corner of Davygate and St Sampson's Square in 1896. Brown's is there now.

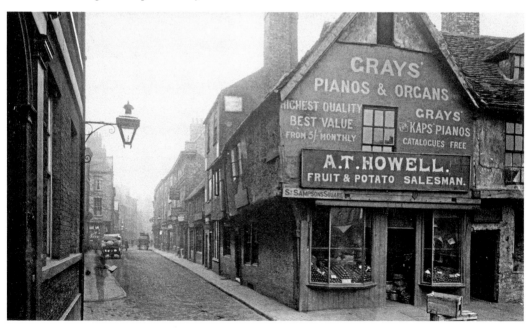

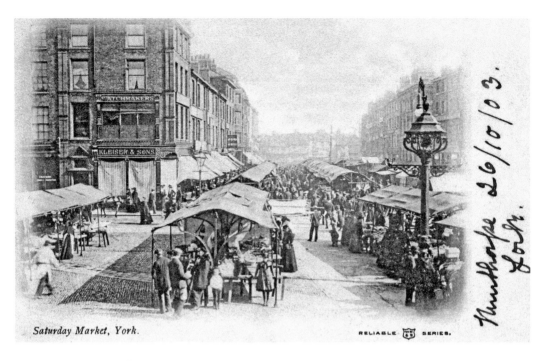

Saturday Market, York.

RELIABLE SERIES.

Parliament Street Market

Two cards, one from 1886 and the other from 1903, showing the heaving Parliament Street Market. An 1833 Act of Parliament gave licence for the market to open; the first was held in 1836.

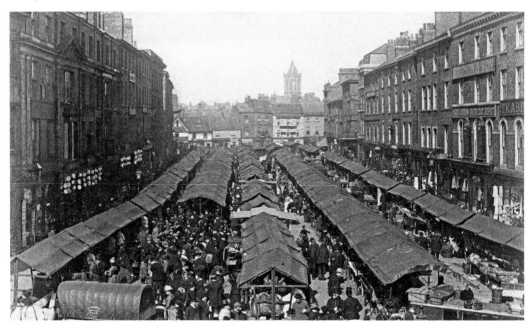

Ken Spelman's Antiquarian Bookshop and Little Apple Bookshop

York was a major centre in the UK for publishing and bookselling, third only to Oxford and London. Therefore, it is a great shame that today very few of York's bookshops and printers survive. These two advertising cards show Ken Spelman's superb antiquarian bookshop and the surprisingly big Little Apple Bookshop – York's last remaining independent bookseller. The area around Minster Gates, the top of Stonegate, and Petergate was brimming with booksellers and printers, as attested by the statuette of Minerva there and the printer's devil halfway down Stonegate.

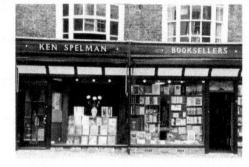
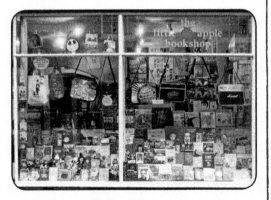
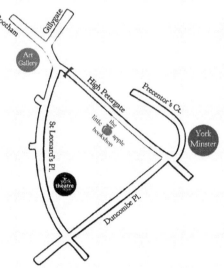

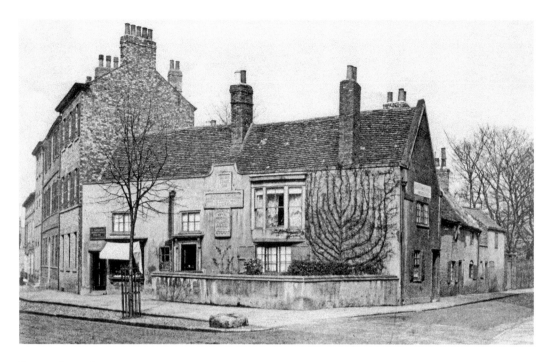

Burton Stone Lane

The original Burton Stone Inn on the corner of Burton Stone Lane pictured here was replaced in 1896 with the pub we see today. At the junction with Bootham there is a somewhat mysterious stone with three holes in it. It may have been a rallying point for soldiers before going off to war or it may be a plague stone. If this were the case then its holes either would have held a cross or been filled with vinegar and deposited coins. The money allowed those quarantined beyond to buy food and the vinegar acted as a primitive disinfectant.

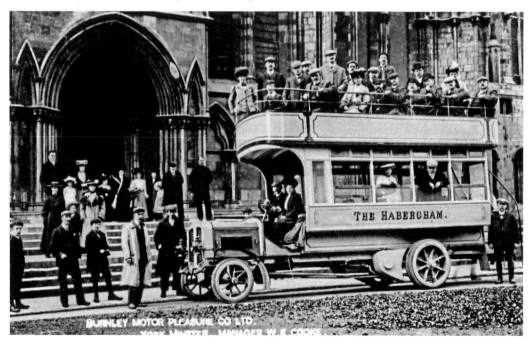

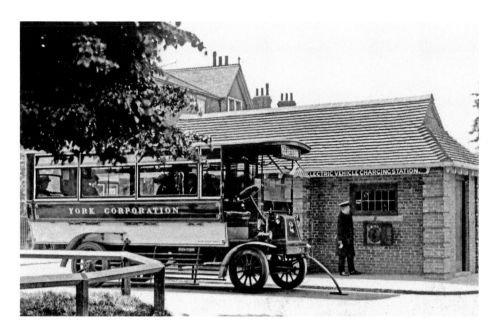

Terry's

A Terry's delivery van and York Corporation Accumulator Station for charging up the electric trams at Clifton. Joseph Terry started making cocoa and chocolate in 1886 and had become the market leader of chocolate assortments by the end of the 1920s. He came to York from nearby Pocklington to serve an apprenticeship in apothecary in Stonegate. In 1823, he married Harriet Atkinson who was related to Robert Berry. He ran a small confectionery business with William Bayldon near Bootham Bar. Joseph then gave up the apothecary and joined Berry in St Helen's Square. George Berry succeeded his father to form Terry & Berry but George left in 1826, leaving Joseph to develop the confectionery business.

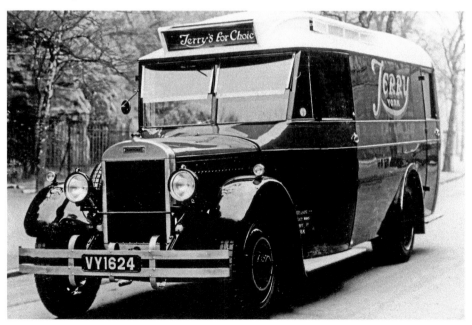

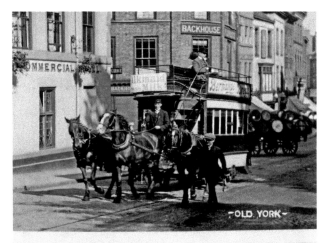

-OLD YORK-

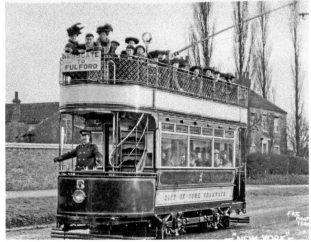

J. Bowman & Sons and Micklegate Hill

J. Bowman & Sons deployed their first steam-powered vehicle in 1909, a Foster 'Wellington' tractor, to pull their existing fleet of horse-drawn vans. Bowman's also had a 'mammoth van' built of sheet steel with wooden wheels, pictured here. According to a company catalogue dated February 1911: 'It has done just on 5000 miles without a mechanical hitch'. Micklegate Hill required three horses for the horse-drawn trams, a trace horse being held in reserve to provide additional horsepower should one of the other two not make it. A horse by the name of Dobbin reputedly did the job for many years, making his own way back down the hill to his post outside the post office until next required.

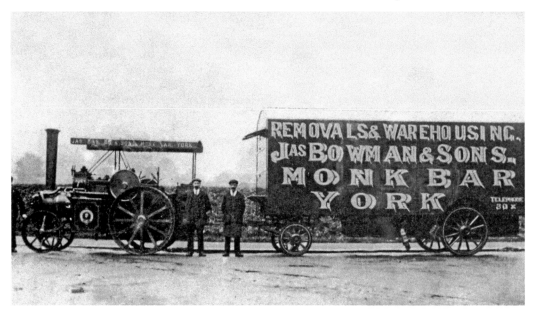

Aldwark

Aldwark in 1962 with a pigeon loft. The whole area was bulldozed and demolished after the enlightened Esher Report of 1968. Aldwark means 'Old werks', or fortification and it was the home of the Merchant Taylor's Guild, Jonathan Martin, the minster arsonist, and of Hunt's Brewery until the 1950s.

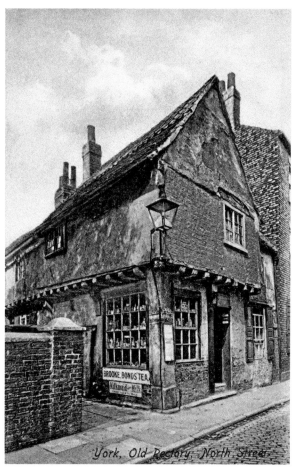

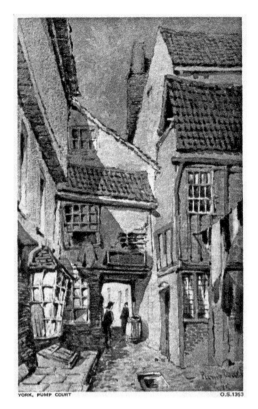

YORK, PUMP COURT O.S.1353

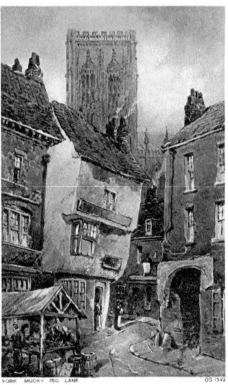

YORK MUCKY PEG LANE OS 1349

Pump Court and Mucky Peg Lane

At the junction of King's Court and Newgate, Pump Court was the site of one of the many water pumps and wells that served the city. John Wesley preached in a room (the 'Oven') here in 1753 (one of twenty-six visits to the city); it became an official place of worship for Methodists in 1754. One of the country's only two surviving lantern tower windows is in Pump Court, tragically, almost hidden from public view. Betty Petre lived here and kept her cattle in the court before slaughter in the Shambles and Mr Huber collected sheeps' guts and washed them in a drain before exporting them to Germany to make fiddle strings. Other residents included a chimney sweep and a prostitute, referred to locally as 'an old knock'. Mucky Peg Lane is thought to be named after a resident of ill repute; other etymologies derive from Pig rather than Peg. We also have a Mad Alice Lane, named after a woman who was executed simply for being mentally ill.

Lady Peckett's Yard and Peter Lane

Lady Peckett's Yard or Passage connects Fossgate with Pavement and is named after the wife of John Peckett, a lord mayor of York. It was called Bacusgail (Bake House Lane) in 1312 and later housed an auctioneers and Richardson's, a moneylender. In 1857, Joseph Rowntree II rented a building in the yard for one of his many adult schools where they taught men to read and write, using scripture lessons; women followed soon after. Mary Kitching was president of the 'B' class of Lady Peckett's Yard Ladies School for fourteen years until in 1892. She left to do missionary work in the Holy Land. A lion from a circus in Parliament Street escaped and was eventually cornered here in the early 1900s. Peter Lane runs between Market Street and High Ousegate and was named after the church that stood here, Eccelsia S. Petri Parva (St Peter the Little), which, in 1585, was united with All Saints in Pavement and was no more. A lane led off from here to the 'Great Shambles' but it was 'stopped up' early in Elizabeth I's reign. On the 29 January, 'the sixteenth of Elizabeth' it was divided 'into twelve parcels for tenements, adjoining it, the occupiers whereof, were to pay a small yearly rent for ever ... and keep it clear of filth'. Peter Lane turns into Le Kyrk Lane, Pope's Head Alley or Peter Lane Little (a nod to the church). At 80 cm wide, this is one of the narrowest and gloomiest ginnels in York, although it is illuminated by an old-fashioned looking lantern. The light at the end of the tunnel is High Ousegate.

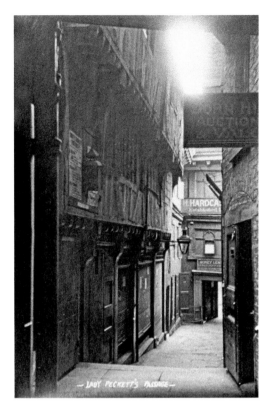

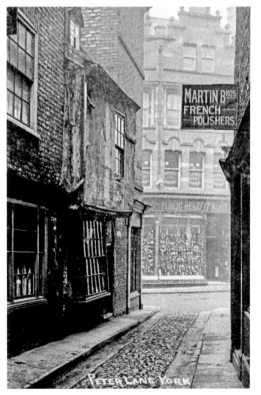

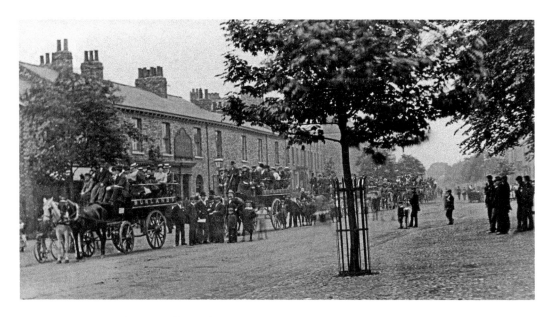

Lawrence Street and Cromwell Road
Members of York's Conservative Party outside the Tam O' Shanter in Lawrence Street in 1901, about to set off for a trip to Buttercrambe Woods near Stamford Bridge. Transport was supplied by John Burland of Fetter Lane. The lower card shows a shepherd with flock on Cromwell Road near Baile Hill in 1911.

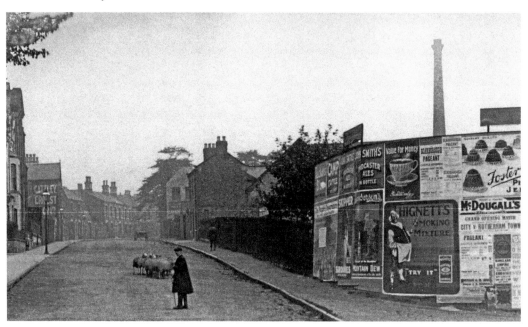

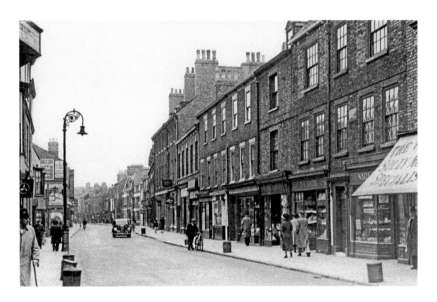

Gillygate and Goodramgate

Gillygate in the early 1940s looking towards what is the now the University of York St John. Norman Anker's garage on the left is now the site of a fish and chip shop. Gillygate was originally called 'Invico Sancti Egidi', then Giligate in 1373 after St Giles Church. The church was demolished in 1547 and the old Salvation Army citadel opened by General Booth in 1882 stood on the site until 2015. Clarence Street houses and nearby Union Street car park were built on land in 1835 called the Horsefair; three horse fairs were held here every year.

The card below shows Goodramgate in 1893 before the demolition of the shops on the left to provide access to Deangate. It is named after Guthrum, a Danish chief active around 878. In 1901, York Minster gave permission for Deangate to pass close to the south transept, linking Goodramgate with Duncombe Place and High Petergate. In time, this led to over 2,000 vehicles per hour passing close to the minster. It was closed to traffic in 1991. Todd's, the tea dealers and grocers, is now the National Trust shop. John Wharton's at No. 87, the Cheap Shop, is the equivalent of our pound shops.

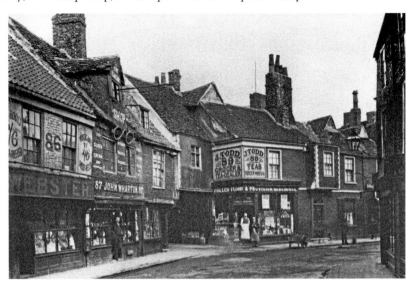

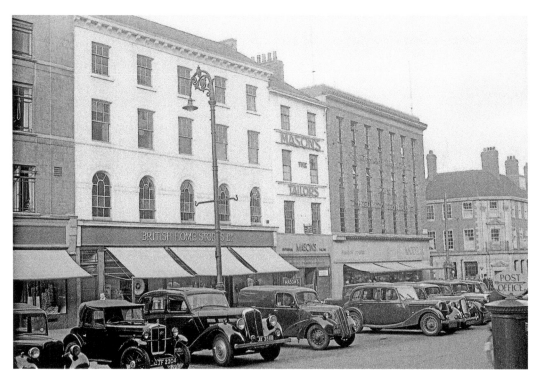

Parliament Street and Micklegate

A splendid array of parked cars in Parliament Street above an equally splendid card showing Micklegate in around 1904. Micklegate House is on the right, built in 1752. Parliament Street is named after the Act of Parliament of 1833 that allowed the market here. Micklegate means Great Street; it originally was Myglagata.

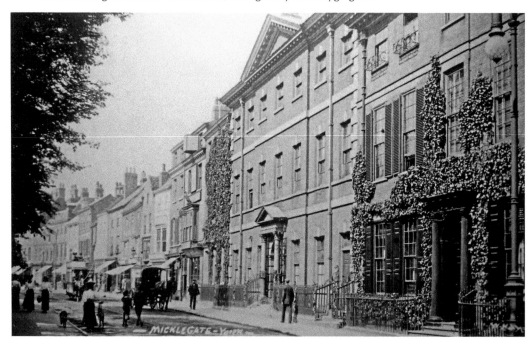

Stonegate

Stonegate in the early 1900s, and in a LNER card from 1930 by Fred Taylor. It is, by common consent, one of the finest streets in England, if not Europe, and York's first 'foot-street', pedestrianised in 1971 and paving the way for many more. You can still see the gallows sign of the Olde Starre Inne stretching across the street. Stonegate was once famous for its coffee shops, hence Coffee Yard. The old Roman stone paving – hence the name – survives under the cobbles complete with the central gulley for the chariots' skid wheels. It was the Roman *Via Praetoria*.

YORK. STONEGATE & MINSTER

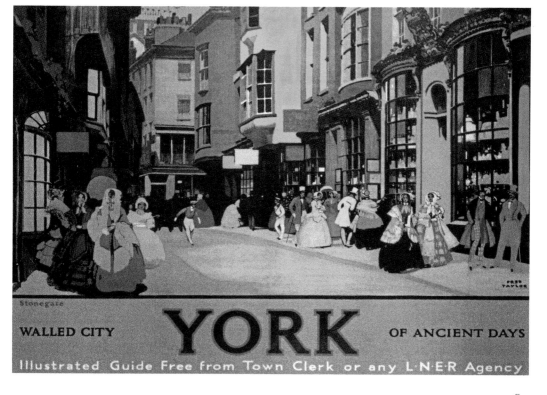

Stonegate

WALLED CITY **YORK** OF ANCIENT DAYS

Illustrated Guide Free from Town Clerk or any L·N·E·R Agency

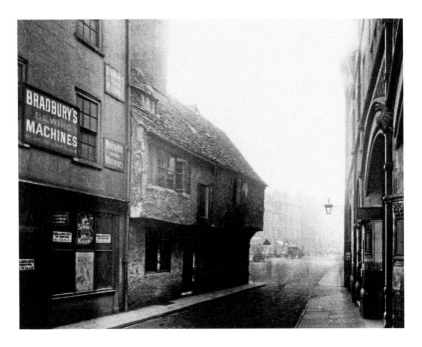

Stonegate and Davygate

This card below shows Stonegate in 1905. The upper card is Davygate in 1895 looking on to Parliament Street on the corner where Browns now stands. Browns was founded by Henry Rhodes Brown in 1891 and has been here since 1900. Davygate is named after David le Lardiner, the clerk of the kitchen. His job was to stock the king's larder. In the twelfth century, David's father, John, was the royal lardiner for the Forest of Galtres, a title that became hereditary, with David received land from King Stephen in 1135. Davygate was also the site of the forest courthouse prison, the only one in the land for incarcerating transgressors of forest laws. The unusual fifteenth-century canopy over the door of the Jacob's Well on Trinity Lane was taken from The Wheatsheaf in Davygate, at one time the residence of the bishops of Durham.

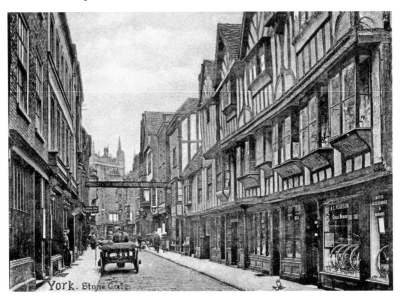

The Shambles

Two cards showing two very different illustrations of the Shambles – probably York's most famous street. The full colour LNER card is a romantic interpretation by VL Danvers from around 1924; the street was never that clean back then. The upper card shows The Shambles on either side of the street near to where the children are standing. The Shambles was originally called Haymongergate to reflect the hay that was here to feed the livestock before slaughter. After this, it was called Needlergate after the needles made here from the bones of slaughtered animals. It gets its present name (at first The Great Flesh Shambles) from the fleshammels – a shammel being the wooden board butchers used to display their meat. They would throw their past-sell-by-date meat, offal, blood and guts into the runnel in the middle of the street to add to the mess caused by chamber pot disposal from the overhanging jetties. There were four pubs: The Globe (closed in 1936), The Eagle and Child (here on the right, closed in 1925), The Neptune (closed in 1903), and The Shoulder of Mutton (closed in 1898). The street is narrow by design, to keep the sun off the meat.

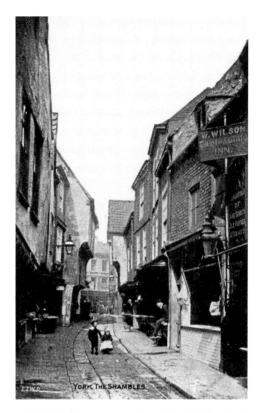

YORK. THE SHAMBLES

CENTRE OF A GLORIOUS HOLIDAY DISTRICT
Illustrated Guide free from Town Clerk York
or any LNER Agency

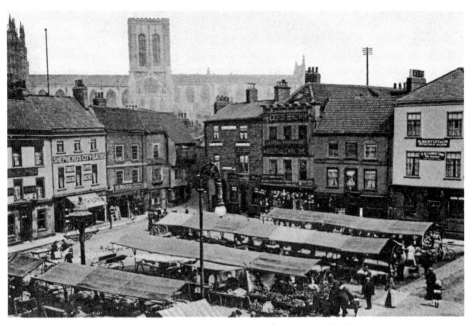

St. Sampson's Square, York — circa 1900

St Sampson's Square and St Helen's Square

A slave market is said to have existed in St Sampson's Square during the Roman occupation. Later, Bede tells us that Pope Gregory I (d. 604) admired English slaves, punning *'non Angli sed angeli'* – 'they're not Angles, but angels'. St Helen's Square is in the lower card with a Terry's van outside the restaurant, on the right, and the Mansion House. During the Civil War Cromwell's army 'shot well nigh forty Hot Fiery bullets' into the square, one of which 'slewe a maide'. The square was the venue for the Thursday hardware market and boasted a fine market cross until its senseless demolition in the 1830s. Plays were staged here on the upper floor.

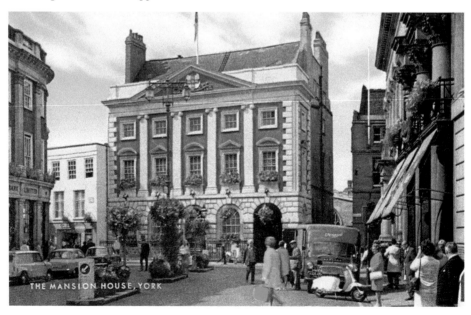

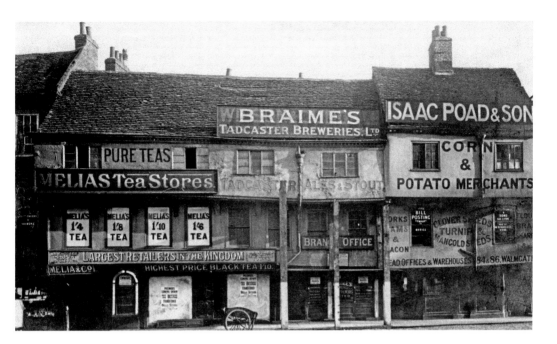

Pavement

Two marvellous shots taken around 1910 showing Pavement with shops, a falling-down pub
and All Saints. Everything was demolished to make way for Piccadilly, although Isaac Poad
continued to trade in the city until the 1970s.

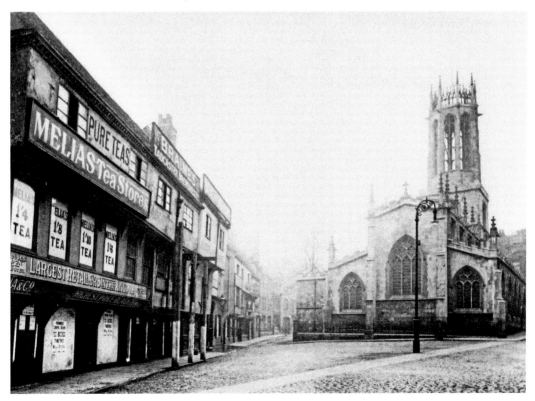

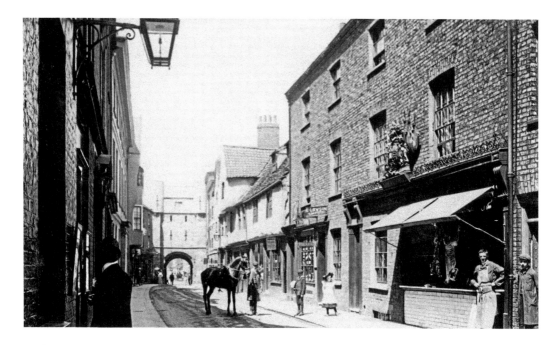

High Petergate and Fossgate

High Petergate looking towards Bootham Bar in 1905 and Fossgate in the same year. The Bluebell, York's smallest pub, is in Fossgate. It was built in 1798 when the back of the pub faced on to Fossgate and the front was in Lady Peckett's Yard. The Rowntree's were responsible for turning it around in 1903 because one of their adult schools was in Lady Peckett's Yard. York City FC held their board meetings here and in the Second World War, it served as a soup kitchen. Women were barred from the public bar until the 1990s.

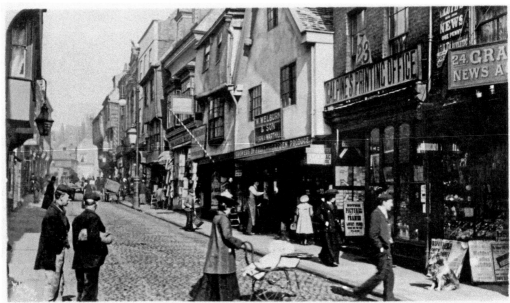

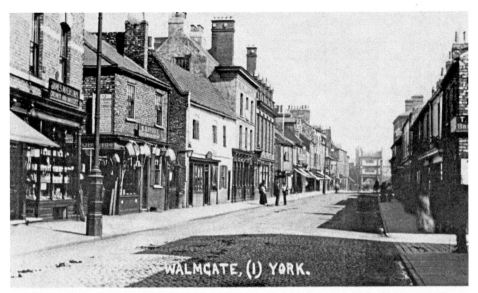

P5 WALMGATE c.1905-1909 NORTH YORKSHIRE COUNTY LIBRARY

Walmgate and Low Petergate

Walmgate with the bar in the distance around 1905 and Low Petergate in 1886 on the corner with Goodramgate and the minster towering in the background. As a result of Seebohm Rowntree's landmark work *Poverty,* published in 1908, York's medical officer, Edmund Smith, produced reports condemning streets in Hungate and Walmgate as unfit for habitation in 1914:

> The back yards in Hope Street and Albert Street and in some other quarters can only be viewed with repulsion – they are so small and fetid, and so hemmed-in by surrounding houses and other buildings ... There are no amenities; it is an absolute slum.

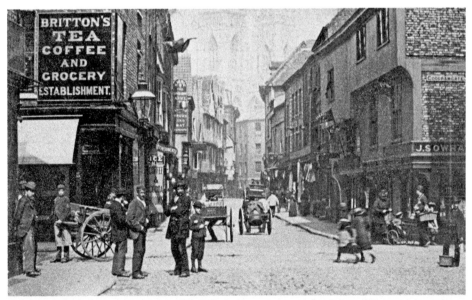

P1 LOW PETERGATE FROM KING'S SQUARE c.1880 NORTH YORKSHIRE COUNTY LIBRARY

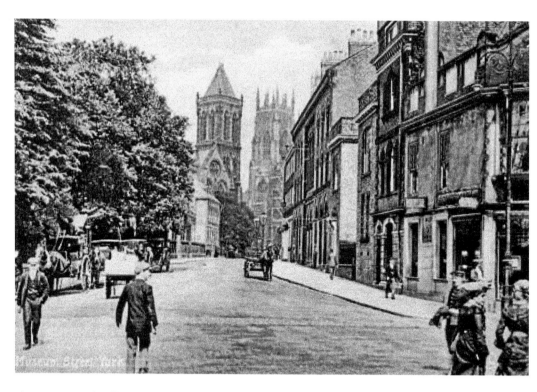

The Junction of Gillygate and Claremont Terrace, and Museum Street
The junction of Gillygate and Claremont Terrace in 1902, looking into Clarence Street. The lower card shows Museum Street with St Wilfrid's Cathedral and the minster jostling for space in the background.

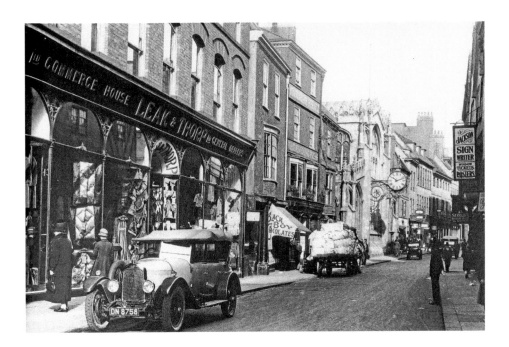

Coney Street

A rainy Coney Street with the majestic clock of St Martin-le- Grand prominent on the left. The Northern Bagnio was down Leopard's Passage, opposite St Martin's; it dates from 1691. The *London Gazette* of 19 October announces it as follows: 'Laconicum Boreale or the Northern Bagnio...where all persons who desire the same may be admitted to sweat and bath; and be cup'd (if they please) after the German fashion ... paying 5s a piece'. By 1735 it had become Alexander Staples' printing office for the *York Courant*, later Ward's the organ builders, but was demolished in 1924. The photo on the upper card is further up the street with Leak & Thorp and the *Yorkshire Herald* on the left.

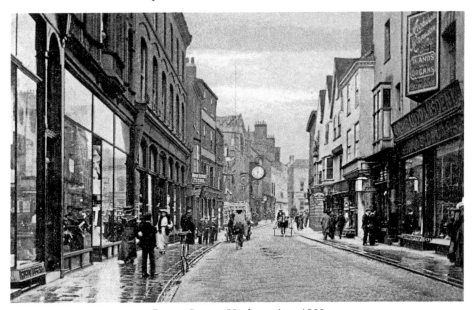

Coney Street, York — circa 1900

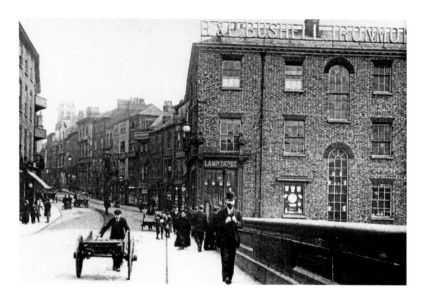

Ouse Bridge

Ouse Bridge in 1905 with handcart and gentleman. Bushell's is on the site of Boyes. The devastating fire here on 8 November 1910 started on the second of six floors when paper decorations in the toy department were set alight by a nearby gas lamp. Despite the best efforts of the fire brigade, assisted by the Rowntree Fire Brigade, the building was a smouldering shell six hours later. Boyes' Scarborough store also burnt down in 1914. The old shop had been trading since 1906; Boyes' new shop was completed in July 1912 and closed down in 1983, to reopen in Goodramgate in 1987. The lower card shows Micklegate and the entrance to the Alien Benedictine Priory before it was demolished to make way for Priory Street.

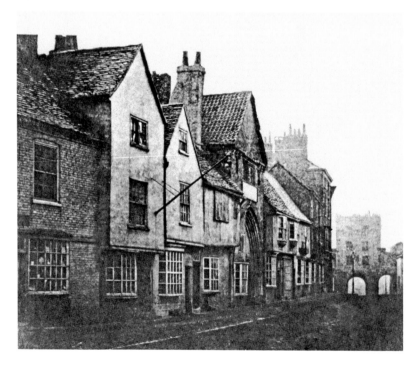

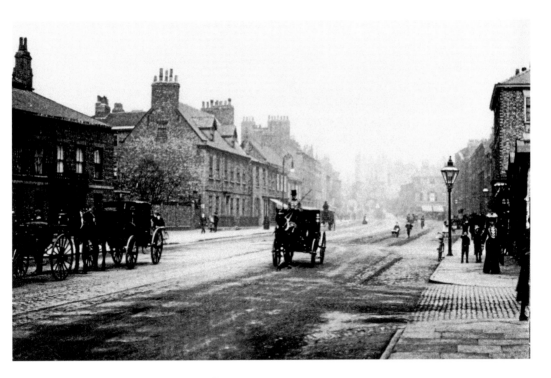

Blossom Street and Whip-Ma-Whop-Ma-Gate

Blossom Street, roughly where the Odeon now stands, and Whip-ma-whop-ma-gate at its junction with Collier Street in 1956. Blossom Street, formerly Ploxamgate, Ployhsuaingate and Ploxswaingate, was the street of the ploughmen. Collier Street is named after the charcoal burners who frequented here, and tiny Whip-Ma-Whop-Ma-Gate: call that a street?

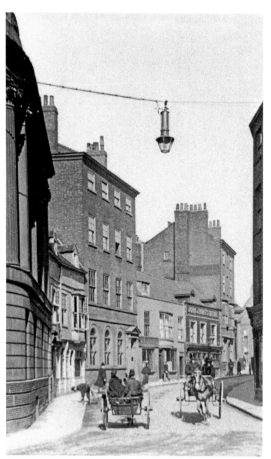

Blake Street and Jubbergate

Blake Street in 1904 on the upper card. One of the earliest neoclassical buildings in Europe is in Blake Street: the 1732 Assembly Rooms were designed by the Earl of Burlington in the Palladian style. They were paid for by subscription to provide the local gentry with somewhere sumptuous to play dice and cards, dance and drink tea, as featured in Smollett's *The Expedition of Humphrey Clinker*. The building epitomised the age of elegance and helped make York the capital of north-country fashion – a northern Bath.

Beneath that is a 1920 shot of Jubbergate. York's first police station was on the left until 1880 when it moved to Clifford Street – originally Joubrettagate, the Street of the Bretons in the Jewish Quarter, and Jubretgate. Over the years, occupants have included Webster's kitchen and bathware shop, which became Pawson's, specialists in rubber-ware. The White Rose Inn became Orrington's furnishers around 1920, who hired out perambulators. At one stage in its life, the building was home to six families.

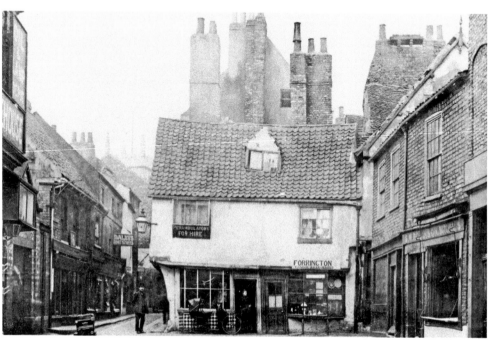